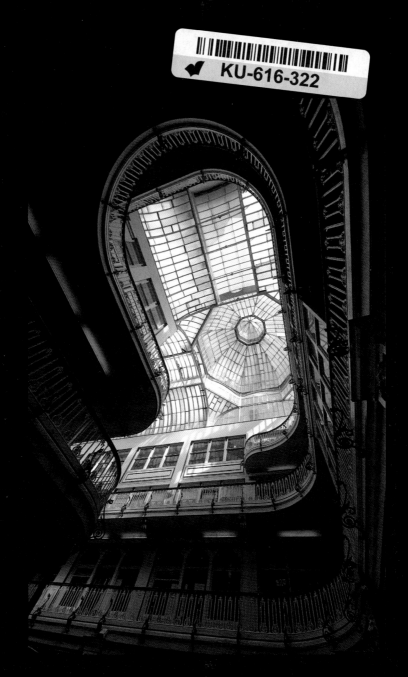

**Arcade (above)**

Interior of the Barton Arcade, Manchester. In the original image, colours were muted but this black-and-white conversion – reducing the image to tone, line and form – strengthens the feeling of light cascading through this Victorian building and that the viewer is within a light-filled space.

**Photographer:** David G Präkel.

**Technical summary:** Nikon D100, Sigma 10–20mm f/4-5.6 EX DC HSM super wide-angle zoom at 10mm, 1/160 at f/6.7, ISO 200, conversion based on Adobe Lightroom Antique Greyscale preset.

# Contents ▷

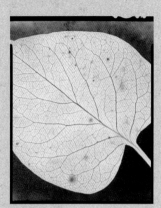

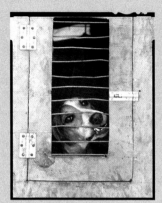

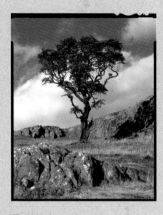
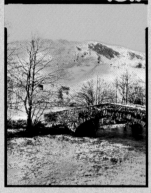

This book covers all aspects of black-and-white photography with both film and digital cameras. Dedicated chapters explain the basic theory of how colours become greyscale tones in a black-and-white image and how you can to learn to 'see' in black and white.

The aesthetics and possibilities of the great themes of black-and-white photography are explored early on in the book. Later chapters look at how to capture black and white using film cameras and how to convert existing digital colour files into strong black-and-white images. As black and white deals only with the presence or absence of light, special emphasis is placed on the qualities of light and on how to control and meter it for the best black-and-white imagery. The subjects of toning and the reintroduction of colour into monochromatic images have a dedicated chapter.

The book is illustrated throughout with creative, thought-provoking images from contemporary practitioners and classic sources. Wherever they occur, technical concepts are identified and explained in an uncomplicated manner on the page and in a concise glossary.

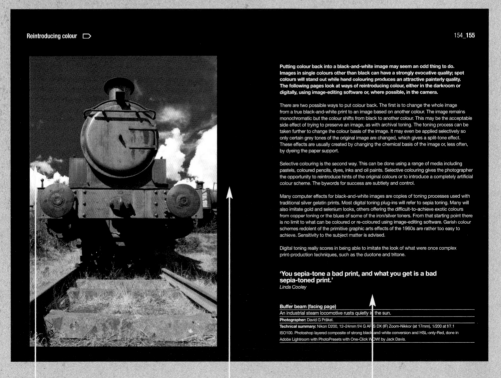

Reintroducing colour  ▷                                                                    154_155

Putting colour back into a black-and-white image may seem an odd thing to do. Images in single colours other than black can have a strongly evocative quality; spot colours will stand out white hand colouring produces an attractive painterly quality. The following pages look at ways of reintroducing colour, either in the darkroom or digitally, using image-editing software or, where possible, in the camera.

There are two possible ways to put colour back. The first is to change the whole image from a true black-and-white print to an image based on another colour. The image remains monochromatic but the colour shifts from black to another colour. This may be the acceptable side effect of trying to preserve an image, as with archival toning. The toning process can be taken further to change the colour basis of the image. It may even be applied selectively so only certain grey tones of the original image are changed, which gives a split-tone effect. These effects are usually created by changing the chemical basis of the image or, less often, by dyeing the paper support.

Selective colouring is the second way. This can be done using a range of media including pastels, coloured pencils, dyes, inks and oil paints. Selective colouring gives the photographer the opportunity to reintroduce hints of the original colours or to introduce a completely artificial colour scheme. The bywords for success are subtlety and control.

Many computer effects for black-and-white images are copies of toning processes used with traditional silver gelatin prints. Most digital toning plug-ins will refer to sepia toning. Many will also imitate gold and selenium looks, others offering the difficult-to-achieve exotic colours from copper toning or the blues of some of the iron/silver toners. From that starting point there is no limit to what can be coloured or re-coloured using image-editing software. Garish colour schemes redolent of the primitive graphic arts effects of the 1960s are rather too easy to achieve. Sensitivity to the subject matter is advised.

Digital toning really scores in being able to imitate the look of what were once complex print-production techniques, such as the duotone and tritone.

'You sepia-tone a bad print, and what you get is a bad sepia-toned print.'
Linda Cooley

Buffer beam (facing page)
An industrial steam locomotive rusts quietly in the sun.
Photographer: David G Pråkel
Technical summary: Nikon D200, 12–24mm f/4 G AF-S DX (IF) Zoom-Nikkor (at 17mm), 1/200 at f/7.1 ISO100. Photoshop layered composite of strong black-and-white conversion and HSL-only-Red, done in Adobe Lightroom with PhotoPresets with One-Click WOW! by Jack Davis.

**Images**
All images have been carefully chosen to show only the theory or technique that is being discussed.

**Main chapter pages**
Special chapter introductions outline the major ideas that will be discussed.

**Quotations**
The pertinent thoughts and comments of famous photographers and artists.

## Headings

Each important concept is shown in the heading at the top of the page, so you can quickly refer to any topic of interest.

## Diagrams

Diagrams, charts and screen-shots are used to explain and support key technical concepts clearly and concisely.

---

The art of black and white ▷

Older cameras/lenses for a unique look   58_59

### Older cameras/lenses for a unique look

Digital black-and-white editing opens up immense possibilities. You can produce images that are not limited by the look of traditional darkroom techniques. However, when it comes to digital capture there are limitations to the look of the black-and-white images produced. Modern digital cameras are fitted with quality lenses that produce great depth of field, low distortion and good resolution. There is also inherently much greater depth of field with smaller image formats. Sometimes this is not what you want. Modern lenses with a multi-blade iris can produce angular geometric highlights that look quite unlike 'older' lenses. Though these cameras and old style lenses give pleasing results with colour, their real 'look' is the one combined with the purity and timelessness of black and white.

A photographer can intentionally recreate an 'old-fashioned' look, but it is easiest using 'old-fashioned' equipment and materials. The flare and softness of an old lens gives a distinct quality that cannot readily be imitated by digital means. A larger-format negative will mean a shallow depth of field even with the lens stopped down. It is easy to expose film in an old camera and later scan the film. Being dogmatic about film or digital is not productive. Blending the technologies for their specific strengths has produced some of the finest images. To get the best of both worlds, an old silver-rich film (such as one that is not a modern tabular grain or **chromogenic** black-and-white film), exposed with an old-fashioned, soft-focus portrait lens can be scanned, enhanced and printed digitally. Many of the smaller film companies still producing film in Eastern Europe on older machinery make film that has rich blacks with plenty of shadow detail, attractive grain and creamy smooth tones.

Many older cameras have lenses with unusual, often distinctive qualities. Polaroid picture roll cameras of the 1948–1963 era (like this Model 110a) are commonly cut about to take Polaroid pack film (picture roll was discontinued in the mid-1980s). More adventurous 'hackers' modify these cameras for roll film to produce oddities such as 6 x 10cm panoramics. They even fit 5 x 4in film backs to a camera designed to cover 3.25 x 4.25in, the resulting light fall-off (**vignetting**) just adding to the 'look'.

**chromogenic** photographic process using chemical couplers to create coloured or black-and-white dye images from the original silver image that they replace. Black-and-white film that is developed in colour chemistry
**vignetting** light fall-off towards the edges of an image – sometimes a lens fault, sometimes done to 'age' the look of an image by edge burning

**Lene (above)**
Outdated material, an older camera converted to use this material and modern digital scanning combine to produce a unique portrait.
Photographer: Gerald Chors.
Technical summary: Polaroid 110a picture roll camera converted to Polaroid pack film by Four Designs Company with 127mm, f/4.7, 4-element Rodenstock Ysarex lens. Scanned positive image from 667 pack film paper negative.

---

## Running glossary

A running glossary is included where each initial use of a technical term or phrase is explained at the point at which it first appears.

## Image captions

Captions provide the creative and technical background to the image chosen and give a technical summary of the camera, exposure details and any post-production work done.

People come to black-and-white photography through one of two very different routes. One group has served an apprenticeship through black and white. It was the film in their first camera. They learned their craft using black-and-white film and it was fundamental to their understanding of photography. For a second, newer generation, however, black and white is seen as an alternative process, something to be produced from colour images either in the camera or on the computer.

There are numerous groups devoted to black-and-white photography on the social and image-sharing networks on the Internet. One recently ran a discussion entitled 'Why do black-and-white?'. A quick unscientific survey of the results suggests that many people have adopted black-and-white photography for subjective, emotional reasons. The words that crop up repeatedly in their answers are 'classy', 'cool', 'retro' and 'moody'. Turn to the professionals and you will find, for instance, that wedding photographers still choose to shoot some of their images in black and white because it has a 'timeless' quality.

Black and white is all these things but it is also something more. Some critics say there would have been no need for black-and-white photography, had colour come along first. But black and white has been both the soul and conscience of photography since its inception. Black and white gets to the core of what is important in an image, leaving behind the distractions of colour.

So, it seems, 'black and white' means two very different things to two different groups. For one group it is something elemental and is at the heart of photography. For another it starts as a 'neat' look. Hopefully, this book can show that black-and-white photography can speak longer and louder in its images about the things that matter.

**Basic theory**
Chapter one looks at how colours become the grey tones of a 'black-and-white' image and gives a historical context to the origins and heritage of black-and-white photography. It looks at the use of colour filters and concludes with a look at contrast.

**The art of black and white**
Black-and-white photography has a special strength not shared by colour imagery – this section looks at some of the great themes explored by photographers and considers how older photographic equipment can be used to produce a unique 'look'.

**Lighting**
The quality and direction of light is vital to black-and-white imagery. This section discusses how important it is to recognise these aspects. Brightness range and metering for the best exposure, lighting for high- and low-key images and use of infrared are all discussed.

**Capturing black and white**
This chapter considers the unique qualities of film images and the use of different film and developer combinations. Previsualisation, the Zone System, tonal range, film grain and digital noise are all explained and explored.

**Realising the image**
This part of the book is devoted to making the best quality printed image, be it from a film negative or digital file. Special consideration is given to the crossover between the digital world and the traditional materials and techniques of the darkroom.

**Reintroducing colour**
Colour can be very powerful when reintroduced selectively into the monochromatic image. Techniques for working on prints with pastels, pens and oils are discussed, as well as methods of colourising digital black-and-white images with real control.

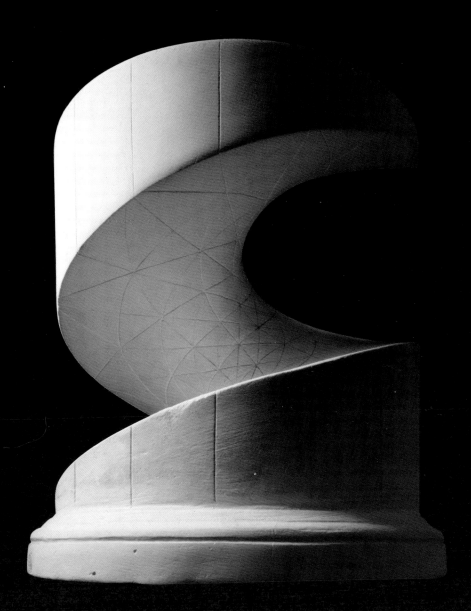

**Conceptual Forms Mathematical Forms 0001 Helicoid Minimal Surface, 2004**
'Art resides even in things with no artistic intentions' – Sugimoto uses both the power and
sensitivity of black-and-white photography to depict the simple splendour of these objects –
sculptures created at the end of the nineteenth century and used in the teaching of
mathematics to explain complex trigonometric functions.

**Photographer:** Hiroshi Sugimoto.

**Technical summary:** None available.

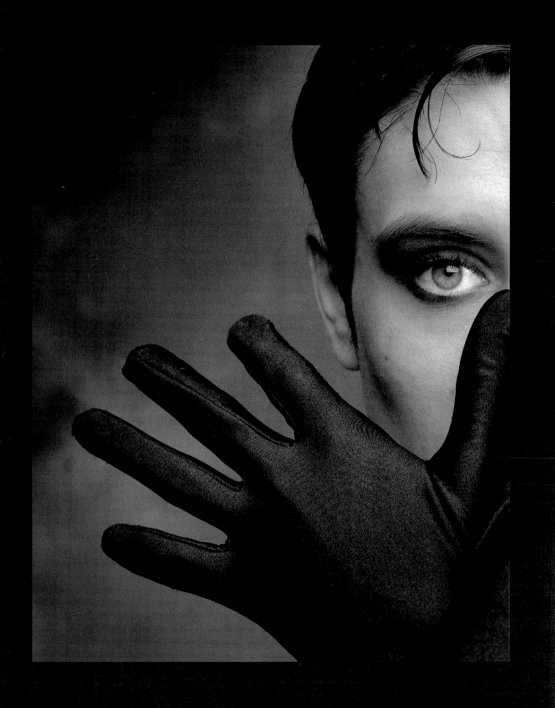

It has to be said at the outset that there is no such thing as black-and-white photography. 'Black and white' is the time-honoured name given to images that contain a range of tones, from paper white through light, mid- and dark greys to dense black. The digital era has given us a new, more precise name: the greyscale image.

Projected images have been with us for a long time. The camera obscura – the original darkened room or chamber from which the modern camera takes it name – had been known in the Middle East since the end of the first millennium. Here a pinhole created a dim, inverted colour image of the outside world inside a darkened chamber. Using lenses of rock crystal to 'throw' and focus an image dates back a further 1,500 years. A method of capturing and making permanent these projected images must have long intrigued the people who first discovered them.

The difficulties of capturing different wavelengths of light to reproduce colour was way beyond the capabilities of the pioneers who tried simply to capture the presence or absence of white light. Early experimenters in the middle of the nineteenth century worked with materials that changed when light fell on them – some materials hardened when exposed to light, some turned black. The former materials were eventually employed in the printing industry to produce printing plates, where ink stuck to the hardened gums produced by intense UV light in the form of an image. The latter gave us the whole traditional wet film photographic industry, on which silver chemistry is based.

Black and white is not just an apology for a colour image – in many ways it is more powerful. Though not a depiction of the way we see, it could be thought of as a depiction of the way we think. It simplifies and produces a new clarity by applying one degree of abstraction – removing colour to leave only tone. It is like taking away the skin to reveal the musculature, bone and sinews beneath.

## 'Black and white are the colors of photography. To me they symbolize the alternatives of hope and despair to which mankind is forever subjected.'
*Robert Frank (Swiss-born American photographer)*

### Blackbird (facing page)
The immediacy and impact of a full-toned black-and-white image.

**Photographer:** Nana Sousa Dias.

**Technical summary:** Wista DXII 4 x 5in view camera with Nikon W 210mm f/5.6 lens, Kodak TMax 100 film, exposure not recorded.

# Black and white and greyscale

A conventional colour photograph is made up of tiny clouds of cyan, magenta and yellow dye that overlap to produce all visible colours. Where there is no dye, the white paper shows; where all the colour dyes overlap at full strength the effect is like black ink. For digital display the colours are coded as numbers, with conventional 24-bit colour images having 256 levels of each of red, green and blue – the additive primary colours of white **light** – giving a palette of 16.7 million potential colours.

A greyscale or 'black-and-white' image mimics the sensitivity of the human eye to colour (this is an issue that will be dealt with in more detail later in the book). Black-and-white film does not react equally to all colours in the spectrum; different films react quite differently and give different 'versions' of the grey tones in a colour image. Similarly with digital files, there are various ways to convert colour to tonal information – best results are from techniques that take into account the sensitivity of the human visual system to different colours.

A true black-and-white image such as the one shown bottom right contains no grey information at all and is an exaggeration of the colour-to-greyscale process, showing only the bare bones of the image, the shapes and lines that underpin areas of **tone**. Without tone, the picture can look very flat. In the darkroom, this kind of image can be made with line film; with imaging software it is made by converting a greyscale image to a bitmap. The setting for threshold gives some control over which grey tones become black and which become white.

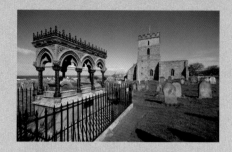

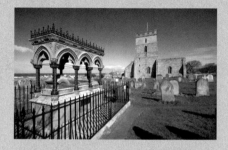

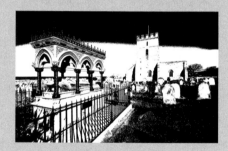

**Grace Darling's tomb and Bamburgh Church, Northumberland**

Colour original (top) with derived greyscale (middle) and bitmap (bottom) images produced in Adobe Photoshop.

**Photographer:** David G Präkel.

**Technical summary:** Nikon D100, Sigma 10–20mm, 1/500 sec at f/8, ISO 200.

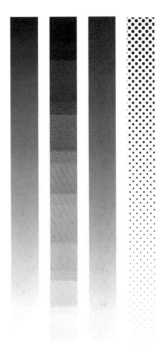

Techniques for reproducing
continuous tone with only black
ink. Greyscale ramp, dither
pattern, random dither, round
halftone dots (left to right).

The only purely black-and-white computer image is the bitmap, which comprises an array
of binary digits; information about black and white only. Bitmaps need not be solid blocks of
black and white. They can be made to convey the appearance of grey by using patterns that
mix black-and-white pixels over tiny areas to simulate different grey tones. Magnified, there
are obvious areas of pattern – but from a suitable distance they appear to be shades of grey in
an image that is made up only of black-and-white pixels – this is known as dithering and the
patterns as dither patterns. This is also how an inkjet printer produces a greyscale image using
only black ink.

Book reproduction of greyscale images uses a process known as halftone screening. Black
ink dots of various sizes combine with the white of the printing paper to give the appearance of
intermediate grey tones. The common halftone uses regular lines of dots, which in practice can
be round, elliptical, square or even diamond shaped; more advanced black-only techniques for
fine-art black-and-white printing use what are known as **stochastic** screens, where the grey
tones are created by random (frequency modulated) patterns, not regular rows of dots.

**light** spectrum of electromagnetic radiation that is visible to the human eye bounded by ultraviolet (UV) and
infrared (IR)
**tone** full range of greys from solid black to pure white
**stochastic** having a random probability distribution – use of random texture screens for printing

## History

The observation that a solution of certain salts of silver darken when exposed to light is usually attributed to the German chemist, Johann Heinrich Schultz, working in the early eighteenth century. This phenomenon was used to create copies of opaque objects such as leaves, and to duplicate portrait silhouettes. Thomas Wedgwood, son of the famous pottery manufacturer Josiah Wedgwood, is known to have used paper soaked in silver nitrate around the early 1800s to make images of fern leaves. The area around the leaf struck by light would darken while the leaf's shadow would remain paper white. But unless kept in the dark, there was no way to make these images permanent. That would have to wait until 1839 and Sir John Herschel, who not only discovered that sodium thiosulphate (hypo) was an effective fixative for the fugitive silver images, but also gave us the word photography from the Greek words for light and the act of drawing or writing: *photos* and *graphien*.

What early workers produced were negatives – images that were dark where the real world was light. The Frenchman Joseph Nicéphore Niépce is credited with being the first person to expose light-sensitive material in a camera in around 1826. Niépce used a bitumen-coated pewter plate that hardened under many hours of exposure to light to give an image. He called his images heliographs – from the Greek words for sun and the act of drawing or writing: *helios* and *graphien*.

The difficulties in reproducing a realistic looking image lay in being able to control a material that reacted differentially to light. Without that control, you could only create a crude shadow picture of dark and light. The concept of producing a weak potential image (called a latent image) which was then treated and chemically amplified (developed), came only after much experiment.

Louis-Jacques-Mandé Daguerre was a French painter who exhibited giant dioramas. He worked with Niépce, until the latter's death, on a process using silver iodide on a polished silver plate. This **photosensitive** plate was much more sensitive than Niépce's heliographs and required an exposure of about 15 minutes. Development was encouraged by fuming the plate with mercury vapour. The image was then fixed and washed. Daguerre named the process after himself – the daguerreotype. Daguerreotypes are mirror image negatives that only appear as positives when viewed at a certain angle where light reflects from the underlying silver plate. Each is a work of art in its own right – unique and quite beautiful. They could only be reproduced by being re-photographed and, being prone to damage, they were usually mounted in cases. Daguerreotypes are exquisitely detailed black-and-white images; the technique attracts some workers even today though the chemicals are dangerously poisonous.

**photosensitive** reacts to visible light (sometimes also to light above and below the visible spectrum UV and IR)

William Henry Fox Talbot, working in England between 1835 and 1845, was the first to produce prints by what we would know today as a negative/positive process. These are sometimes referred to as talbotypes or, more commonly, as calotypes. Fox Talbot used paper that had been photosensitised (made sensitive to light) with silver chloride, exposed in a camera obscura. The latent image was developed with gallic acid and fixed with common salt. These resulting paper negatives had reversed tones. Fox Talbot overcame this problem by placing an unexposed sheet of sensitised paper in contact with the first negative and exposing it to light. After developing and fixing, this positive copy gave an accurate tonal reproduction of the original scene. What is more, Fox Talbot could use the original negative to make more than one positive copy. He produced the first commercially printed, photographically illustrated book, *The Pencil of Nature*, in 1844.

The limitations of Fox Talbot's paper negatives were swept away by Frederick Scott Archer's wet plate collodion process in 1851, which itself led to the silver gelatin and dry plates by about 1880. The flexible film we know today came in around 1889, opening up photography to the mass market. All were based on the negative/positive process until the arrival of the digital camera in 1975, itself a black and white-only device that recorded pictures on to cassette tape.

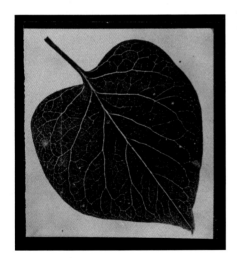 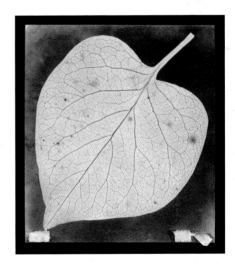

**Single leaf (above)**

Fox Talbot's real contribution to photography was establishing the principle of the negative/positive process and demonstrating that one negative could make many copies. Similar in appearance to a pressed flower, this photogenic (light-made) drawing of a leaf and its negative were made in about 1840.

**Photographer:** William Henry Fox Talbot.

**Technical summary:** 'Photogenic drawing' negative (right) and salt paper print (left). Originals roughly 8.5cm².

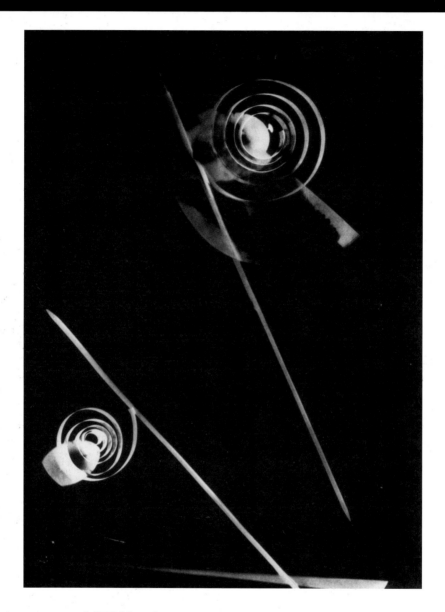

**Photogram, around 1928 (above)**

The Hungarian artist László Moholy-Nagy (1895–1946) used his abstract paintings as a springboard to explore light, transparency, shadows and reflections using photographic printing paper. (He later taught photography and played a major role in photographic education in America in the 1940s.)

**Photographer:** László Moholy-Nagy. (Reproduced courtesy of George Eastman House.)

**Technical summary:** Gelatin silver print, 39.4cm x 30.0cm (ex-collection Sybil Moholy-Nagy).

# Photograms

The very earliest photographic images worked by capturing the effect of shadows left by solid objects on material that was sensitive to light. Where the light fell the material went dark, the shadow being seen in the form of the original, untouched medium. Though an apparently primitive form of imaging (as neither lenses nor pinholes are involved in projecting the image into a camera) the so-called photogram has an honourable tradition in the photographic community. The photogram even has an ardent following among contemporary practitioners. In fact, one of the main websites supporting the photogram defiantly proclaims: 'break free from the tyranny of the lens'. In this spirit, some workers wrap their photosensitive materials around solid objects to get an even more intimate image. Yet others have used X-ray sources and film to produce exquisitely detailed fine-art photograms from what would otherwise be seen only as a technique of medical imaging.

Young children are often encouraged in school to make sun prints. As the name suggests, these rely on the sun's energy as the illuminating source and use blue iron salts rather than black silver. They are then printed using the same paper as that used in the **cyanotype** (though many cyanotype workers mix and sensitise their own materials as part of the control they want over the imaging process). Sun prints are developed in tap water (although hydrogen peroxide speeds the process – but this is becoming more difficult to obtain). Images made up of simple strong shadows can be made more complex when transparent and translucent – sometimes reflective – materials are introduced or the light source is used more imaginatively to rake across the photosensitive material and cast long shadows rather than shine straight down.

Simply because this is such an uncomplicated method of creating images, creativity is at a premium. The choice and combination of materials, the manipulation of the light source and of how the photosensitive material contacts the real-world objects are all variables to be manipulated. A related process is the *cliché verre*, which is essentially a hand-drawn negative. Traditionally, a soot-smoked or black-laquered glass plate is scratched with a sharp point to produce a negative. This can then be contact printed on to any light-sensitive medium – cyanotype paper and silver gelatin papers will both produce images but give very different results. Large sheets of exposed and developed film work equally well and the *cliché verre* technique can be an enjoyable way to use up sheets of outdated film.

So-called Ray-o-grams or Schad-o-grams are photogram images produced by the artist Man Ray (Emmanuel Radnitsky) and painter Christian Schad respectively.

**cyanotype** photographic process using salts of iron rather than of silver. Monochromatic blue/white prints

# Colour to black and white

### The colour wheel

It may seem odd to be considering colour theory as a basis for understanding black-and-white photography. White light comprises all other colours of the visible spectrum while black is the absence of all colours. It is the job of black-and-white film to capture all portions of the visible spectrum – some films do a better job than others. No black-and-white film is perfectly and evenly sensitive to all the colours of the spectrum and each has its own individual 'look'. Some black-and-white films, for example, are more sensitive to blue light and represent blue objects as darker tones than would be expected in the final image.

The primary colours of white light are red, green and blue. These are the colours that cannot be made up by adding light of other colours and which, when added together, make white light. They are therefore known as the additive primaries. Take any one of these colours away from white light and you are left with the cyan, magenta or yellow. These colours can be thought of as white light without red, white light without green and white light without blue, respectively. Based on this idea of taking away one primary colour from white light, the colours cyan, magenta and yellow are known as the subtractive primaries.

**Colour wheel**

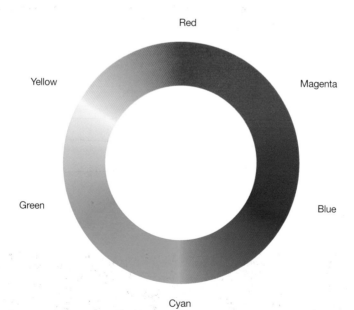

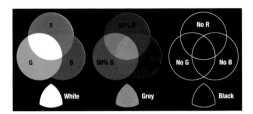

**Additive primaries**

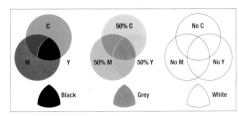

**Subtractive primaries**

Colours that lie opposite across a diameter of the wheel are called **complementary colours**. A colour filter will darken its complementary opposite, while lightening colours similar to its own. For example, skies in the blue to cyan range will be darkened by a filter from the yellow, orange or red range, and yellow-green leaves will be lightened by a similar yellow-green filter. The rule for filters with black and white is: opposite colours darken; similar colours lighten.

Oddly enough, today's digital cameras are still **monochrome**-sensing devices. Their sensors record over 4,000 levels of light across an array of photo-sites. Tiny coloured filters of red, green and blue are laid over the photo-sites in a pattern; different colours in the light falling on the 'chip' in the camera give rise to a different blend of the red, green and blue primary colours, which are then recorded as a number code. Without this filter 'mosaic', digital cameras would be black-and-white-only devices. To record black and white in a digital camera requires the manufacturer to have provided a mode where the channels of red, green and blue are recombined to produce a greyscale image.

**complementary colours** pairs of colours that lie 'opposite' each other on the colour wheel. A filter of one colour will darken its complementary opposite. These are not the same colour pairs as traditional artists' complementary colours
**monochrome** reproduction in the varying tones of only one colour (usually refers to black-and-white photography)

# How colours 'become' tones

Digital cameras are even-handed in their response to colour across the visible spectrum. Their sensitivity sometimes extends further out into the infrared and ultraviolet regions. Because the digital black-and-white image is created from manipulation of the original number-coded colours the specific 'look' is a product of the conversion process and is not inherent in digital capture.

Desaturating a colour image does not produce a satisfactory black-and-white version, though this is commonly suggested as a way of creating black-and-white digital images from colour originals. There are many ways in which to manipulate the digital colour data to produce a black-and-white image – when working in this way, the problem becomes one of choice.

In contrast, each black-and-white film has its specific look. This is a result of each film type having subtly different sensitivities to visible colours. In fact, some of the differences are not so subtle at all. The way in which a film reacts to different colours of the spectrum of visible light is known as its 'spectral sensitivity'. Film can be sub-divided into broad categories of spectral sensitivity. Very early films were sensitive only to blue light; they had a limited sensitivity to green but no sensitivity to red light. These so-called **orthochromatic** films would darken the appearance of white or lightly toned skin, often making pictures of our ancestors look as if they were heavily tanned outdoors folk.

**Spectral sensitivity of different film types**

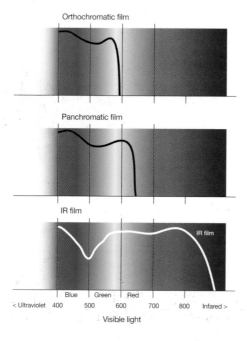

**Panchromatic** film has a much-extended sensitivity towards the red end of the spectrum but still does not respond equally to all parts of the visible spectrum. Within each group of films, there are individual differences. Black-and-white 'pan' films from different manufacturers and with different sensitivities show distinct differences in how they record a colour scene and this can be the basis for personal preference.

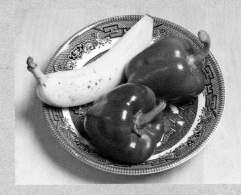

Infrared- or so-called near red-sensitive films show sensitivity out beyond visible red into the infrared region. These are usually exposed through a deep red – sometimes almost black – filter to cut out all blue/green light and much of the visible red spectrum. Sadly, the choice of IR film has reduced significantly in recent years. Kodak's High Speed IR film defined the classic look of infrared images with its ethereal, otherworldly look of black skies and white foliage, but is no longer in production.

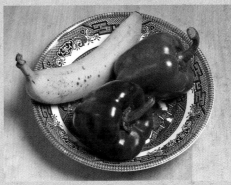

**Colour to black and white (right)**

Digital colour file (top) and greyscale conversion from Adobe Photoshop (middle) and the same scene on black-and-white film (bottom).

**Photographer:** David G Präkel.

**Technical summary:** (Top) Nikon D200 60mm f/2.8D AF Micro Bowens Esprit 500 flash with umbrella f/29, ISO 200; (Middle) Photoshop conversion to greyscale; (Bottom) Leica R8 60mm f/2.8D Macro-Elmarit f/22, Ilford FP4, ISO 125, developed in LC29 for normal contrast.

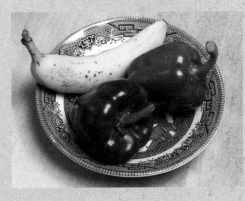

**orthochromatic** photographic emulsion that is sensitive to all visible colours except reds

**panchromatic** photographic emulsion that is sensitive to all colours in the spectrum and sometimes beyond into the ultraviolet and infrared

# Filtration

## Colour filters with black and white

At first, it seems an unusual idea to put a coloured filter over the lens of a camera loaded with black-and-white film. However, the careful choice and use of coloured filters can greatly affect the appearance of the final black-and-white image. Without using filters, some colours may reproduce weakly on black-and-white film, some shades of red and green reproduce as very similar grey tones and skies can often appear overexposed and white. Remember though that filters cut out the light from some part of the visible spectrum to achieve their effect. This means that additional exposure is needed.

Presume that black-and-white film has roughly equal sensitivity to all the colours in the visible spectrum (which is not always the case). Filters let light of their own colour through to the film but block other colours in the spectrum. A strong red filter, for example, blocks a lot of the blue and green light in a scene in front of the camera but allows red light to pass through. Blue and green coloured objects will therefore reproduce darker. As we saw on page 18: to darken any colour, use a filter of the complementary colour (opposite on the colour wheel); to make any colour appear lighter, use a filter of the same or similar colour.

Skies tend to be coloured blue to cyan. So to darken a sky, use a yellow, orange or red filter. In practice, these filters have a progressive darkening effect on skies, with yellow showing the least effect and a strong red filter showing a more dramatic darkening effect. Photographers of an earlier generation would refer to yellow filters as 'cloud filters' as they gave some modelling to the clouds against a slightly darkened sky. Red filters were called 'sky filters' as they had a stronger effect on clear blue skies.

Blue filters can be used to subtly darken skin tones for portraits or nude images – filters from the Wratten 82 series of light-balancing filters are sometimes used to achieve this effect on black-and-white film. A so-called 'spring/summer' filter (a yellow-green filter such as a Wratten 11) can also make the young yellow-green leaves on plants and trees appear lighter and more natural in the final image – a green filter will make them even lighter. A yellow-green filter will also get the black-and-white 'look' right when taking portraits under tungsten light.

Colour filters have a special use in portraiture to subtly alter skin tones and hair colouring. The effects can either be a technical adjustment or can be applied for exaggeration or aesthetic purposes. A yellow filter (Wratten 8) lightens skin tones but maintains a natural look; a deep yellow filter (Wratten 15) will lighten skin tones more distinctly. With a blonde-haired person, the yellow filter will lighten the hair more than their skin tone. Sometimes a darkening effect is useful with men and a light green or green filter (Wratten 56 or 57) will produce this. A green filter will darken red lips but models must have clear skin so as not to exaggerate blemishes. Red filters will remove all appearance of skin blemishes, both smoothing and lightening skin tones (sometimes to an unnatural extent) – they seem also to increase the modelling effect of the lighting, so as to better bring out the shape of the face. With darker skins, blue filters (Wratten 47) will darken and smooth skin tone and will further darken naturally dark hair.

No filter

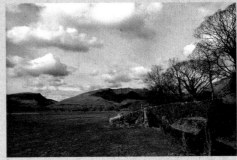

Yellow filter

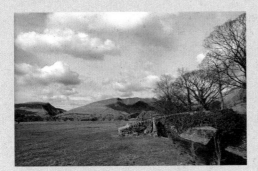

Orange filter

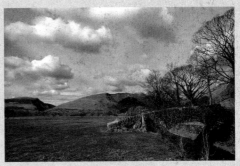

Red filter

**St John's Beck, Cumbria (above)**

Cloud and sky filters all have some effect in darkening the sky – though the progressive darkening from yellow through orange to red can be seen, a darker blue sky than this would produce an even more pronounced effect with the orange and red filters.

**Photographer:** David G Präkel.

**Technical summary:** Nikon FE, 28mm f/2.8 Nikkor 1/250, 1/125, 1/160 and 1/30 at f/22 HP5 Plus rated at ISO 400, developed in LC29.

### ND filters, graduated filters

**Neutral-density filters** are made from plain grey glass or resin (plastics) and are available in a variety of densities. They cut out light equally across all wavelengths. In bright light, they make it possible to take pictures when the camera is loaded with fast film (high ISO); they can also be used to achieve longer shutter speeds or wider apertures. ND filters are particularly useful when you wish to keep the background out of focus in a portrait, for example, on a bright day, when the correct exposure would normally be achieved with a fast shutter speed and a small aperture. An ND filter lets you open up the lens by cutting down the light, thereby reducing the depth of field in front and behind the point of focus. Another common use is to increase the shutter speed on bright days to blur the appearance of moving water in an image. Various densities are produced but the most common are 0.3, 0.6, 0.9, passing 50 per cent, 25 per cent and 12.5 per cent of the light (increasing the exposure by one, two and three **stops** respectively).

**Graduated (Grad)** filters are the best cure for images with washed-out or weak skies. Made from partly toned resin or plastics, slightly more than half of the filter is left clear while the other half is denser, transmitting less light. By putting the denser area over the sky, the photographer can reduce the brightness difference between the sky and the land. This guarantees that the camera records more highlight and shadow detail whether you are using film or digital. Of course, grad filters can be used the other way up in snowy landscapes where the ground is brighter than the sky. Graduated filters are an important camera filter for digital camera users who should not try to rely on the flexibility of the 'raw' file format or Photoshop layers to adjust the brightness range – for best quality this should be dealt with in the camera.

The clear-to-dense area of a graduated filter has a smooth transition; the filter will be rated by the final density it offers, though some manufacturers just refer to their filters as strong, light or medium. A filter that, at its densest, gives a two-stop reduction is called an ND4, or a 0.6 ND filter, or it may be described as having a x4 filter factor; all these mean the same thing. A light, one-stop filter is an ND2 or 0.3 ND with a x2 filter factor, while a very strong three-stop filter is an ND8, 0.9 ND with a x8 filter factor. (As with ND filters, the 0.6 ND two-stop filter probably has the widest application; if you are buying just one, this is the one to go for.)

The length of the transition from dense to clear can vary – a long transition is described as 'soft', a fast transition as 'hard'. Soft transitions are easier to 'hide' in the final image and their presence does not show quite as much. By adjusting where the dense part of the filter and the transition falls, these filters can be used to darken skies or to control contrast. Rectangular grad filters are more flexible than circular screw-in filters as the angle of the graduation can be adjusted in the rotating holder as well as the point at which it enters the frame.

Technically, you need to meter a midtone that falls in the clear part of the filter for best results. Alternatively, you can meter the unfiltered scene: if you are using an automatic or semi-automatic setting, transfer the reading to the camera set on manual and then add the filter. Metering with the filter in place will give an overall lighter effect. Check where the graduation falls and how it will appear by using the depth-of-field preview button if there is one fitted.

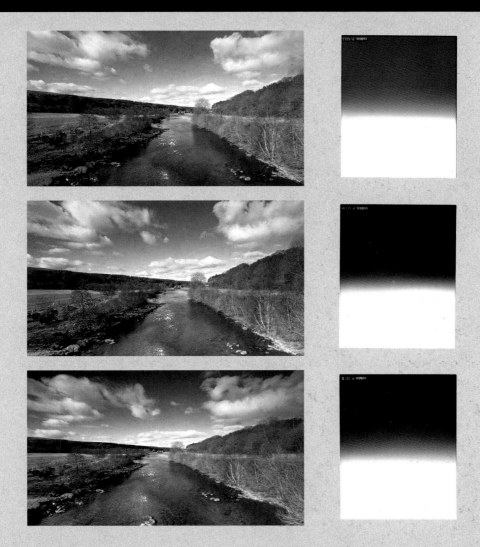

### Bridge at Eals

Light, medium and strong graduated neutral-density filters used to progressively darken the sky and reduce subject brightness range. Scans of actual resin filters are shown alongside.

**Photographer:** David G Präkel.

**Technical summary:** Nikon D100, Sigma 10-20mm f/4–5.6 EX DC HSM super wide-angle zoom at 10mm, all 1/160 at f/8, ISO 200.

---

**neutral-density filter** filter that reduces light intensity equally across the spectrum

**stop** unit expressing ratios of light or exposure where one stop represents a halving or doubling

**graduated filter** partly toned resin or plastics filter with slightly more than half of the filter clear. Clear-to-grey area has a smooth transition. Used to darken skies or control contrast

**Polarisers**

Polarising filters are neutral in colour but give contrast and colour saturation changes as well as controlling or eliminating unwanted reflections (in non-metallic surfaces). As such, they do not work to cut out reflections from mirrors or polished chrome surfaces. Polarisers filter the physical characteristics of light, not its colour. Sunlight spreads in waves from all directions; light waves that are reflected from a smooth surface tend to be orientated in the plane of that surface. A polarising filter has a crystalline structure that lets light through at one angle but not another. One polarising sheet can be rotated against another to block most of the reflected light. Colours will be more saturated by reducing the apparent brightness, while reflections from non-metallic, glass or water surfaces can be eliminated or reduced. However, the polariser must be orientated to work properly.

Polarisers work only in sunlight and 'with the sun on your shoulder'. (In the studio, light can be polarised with gels over the lamps – a common technique for reducing reflections with a copy camera.) In other words, the area of blue sky at right angles to the sun can be darkened by a polarising filter. However, with wide angle lenses a distinct, dark band can show up across the sky. Through-the-lens camera meters usually make appropriate exposure adjustments for the light loss with polarisers. If you are using a medium- or large-format camera, you must follow the filter manufacturer's instructions and usually give an extra one-and-a-third to one-and-a-half stops exposure to compensate. Polarisers come in two types: linear and circular. Linear polarisers are less expensive but are only used with view cameras, manual viewfinder/rangefinder cameras and manual SLR cameras. Circular polarisers are the only polarising filters that work with modern cameras, having TTL meters and auto focus.

Polarisers can be used in combination with red filters to give unreal drama to blue skies, creating night from day. The long exposures that result from the combined filter factors means there must be little or no wind to avoid streaking clouds or trees and plants appearing blurred in the final image as they move during the exposure.

All optical filters (prisms, or diffusion filters, Zeiss-branded 'Softars', soft focus or soft-spot, split-field filters), and many effects filters (cross-star, fog) will work with black-and-white film and with digital cameras where the final image is intended to be reproduced in black and white.

Maximum polarisation

Minimum polarisation

### Sky in the Eden Valley (above)

Minimum and maximum effects of a circular polarising filter – note the dramatic darkening of the sky at right angles to the sun.

**Photographer:** David G Präkel.

**Technical summary:** Nikon D200 18–20mm f/3.5–5.6G VR AF-S DX IF-ED Zoom-Nikkor at 18mm, 1/180 at f/6.7, ISO 100.

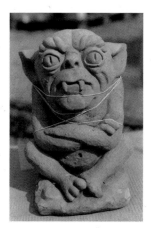

Grade 0

Grade 3

Grade 1

Grade 4

Grade 2

Grade 5

# Contrast

Contrast describes the perceived difference between the dark and light parts of an image. A high-contrast image will consist mainly of dark tones that are close to black and light tones close to white; a low-contrast image will be made up of closely related grey tones without the extremes of the high-contrast image. An image of normal contrast will have a regular distribution of tones from black through the shades of grey to white. Contrast can also be thought of as the rate of change of tones from black to white – something that will be discussed in the next section in the context of contrast curves.

The contrast of digital images can be changed using either the contrast slider or by using a tone curve. With film the contrast can be changed by under- or overexposing the film and consequently over- or underdeveloping it. Full details of how film contrast can be manipulated are given in the section relating to the exposure index on pages 88–89.

A first understanding of photographic contrast usually comes from the darkroom, where variable-contrast paper offers an easy and practical way of experimenting with contrast effects. Technically, the contrast of the printing paper should be matched to the contrast of the negative to achieve a balanced print. However, for good artistic or subjective reasons a different contrast than that which would be technically correct can be chosen.

The contrast of photographic paper is referred to as the grade. Paper needs to be stocked in a variety of grades from high contrast – often described as 'hard', to low contrast – often described as 'soft'. Graded paper is commonly supplied in five grades from 0 (soft) to 5 (hard). Variable-contrast paper means that one paper can be stocked yet a range of contrast effects produced. So-called multi-grade paper has a complex combination of blue- and green-sensitive emulsions that react differently under filtered light. A range of yellow and magenta filters (complementary colours of blue and green) can be used to infinitely vary the contrast grade of hardness of the paper from grade 00 (very soft) to grade 5 (hard). Full details of working with this paper are given on pages 108–111.

**All tied up (facing page)**

Film negative of an unhappy garden ornament printed with different contrast grades: Grade 0 extra soft, grade 1 soft, grade 2 normal, grade 3 hard, grade 4 very hard, grade 5 extra hard.

**Photographer:** David G Präkel.

**Technical summary:** Leica R4 60mm f/2.8 Macro-Elmarit, exposure not recorded, Fuji Acros ISO 100, developed in Ilford LC29, printed on Ilford Multigrade IV RC paper.

## Curves

Manufacturers of photographic materials use graphs to show how their films and photographic papers respond. A **'characteristic curve'** shows how film reacts to light, different development times or developers. These curves plot increasing **exposure** (E) on the horizontal axis (as a logarithm) against increasing density (D) up the vertical axis. They are often called D/Log E curves or H&D curves after the scientists Hurter and Driffield who published the first work on sensitometry at the end of the nineteenth century.

The curve does not start where the axes of the graph cross. It takes a certain amount of light energy (exposure) before any image forms at all – this is called the film's inertia. After this point, you get more density as the exposure increases but film shows three different areas of performance. The initial 'toe' is where big increases in exposure only produce a slow build-up of density. In the linear (straight line) region, equal increases in exposure create equal increases in density (this is where the midtones are recorded). The 'shoulder' region is where density nears its maximum and it takes more and more exposure to produce ever-smaller changes in density.

Films with a long 'toe' can be pushed and show good shadow separation; short 'toe' films build contrast very quickly. The steeper the linear section, the more contrast the film will produce. The slope of the curve is given the Greek letter gamma (γ) (also now used as a measure of the contrast of computer monitor screens). The 'shoulder' area shows how film gently compresses highlight detail. Digital sensors are much more linear. They will rapidly clip information and do not show the same graceful characteristics of film. This is a key difference between the two imaging technologies.

### Film 'characteristic' curve

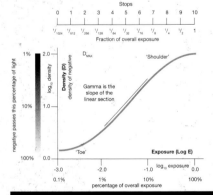

An understanding and knowledge of film's characteristic curves helps when working with the tone curves in digital image-editing software. A lazy S-shaped curve gives gently increased contrast, an inverse S-shaped curve gives reduced contrast. Tone curves can give a precise 'look' to digital black-and-white photographs and form the basis of a lot of the preset looks that can be applied through Camera Raw or Adobe Lightroom conversions of raw colour images.

**characteristic curve** graph showing relationship between the amount of exposure given to a photosensitive material and the corresponding density after processing

**exposure** combination of intensity and duration of light used to allow the right amount of light to reach film or sensor to record full tonal range

Use of strong adjustment curves increases the likelihood of 'running out of numbers' to correctly display a smooth tonal range. The result is visible banding or 'posterisation'. This is a particular problem when manipulating eight-bit images; 16-bit files should be used whenever adjustments are made to the curves or levels. Adjustment layers should be used in preference to the menu commands as layers store potential changes for later editing.

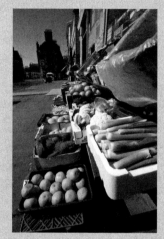

**Normal**

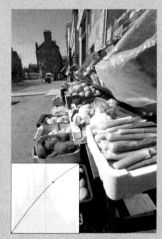

**Lighten**

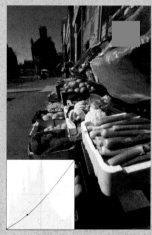

**Darken**

### Edinburgh grocer

The effect of different curves: untouched image for comparison; lighten curve; darken curve; S-shape curve to increase contrast; inverse S-shaped curve reduces contrast.

**Photographer:** David G Präkel.

**Technical summary:** Nikon D100 Sigma 10–20mm f/4-5.6 EX DC HSM super wide-angle zoom 1/400 at f/11, ISO 200.

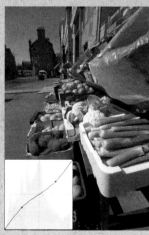

**Reduce contrast**

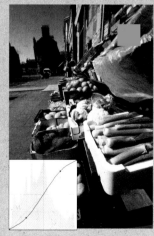

**Increase contrast**

### Histograms – digital

The easy way to understand a **histogram** is to think of the digital image as a 'pixel warehouse'. If you asked a warehouse manager to carry out a stock control check on your pixel warehouse and return a bar chart with the results you would get a histogram. The pixels are divided up into 256 categories of brightness level, from 0 to 255. Black is 0, white is 255 with mid-grey at 128; all dark shades of grey are below 128 and all light shades of grey are above 128. The histogram displays the numbers of each type of pixel. The vertical height is unimportant as the category with the highest number of pixels is always made to fit the maximum vertical height on the screen. On the histogram, black is on the left and white is on the right. Usually the midpoint and quarter/three-quarter tones are marked. (Some cameras show five divisions representing a safe five-stop tonal range.)

There is no perfect histogram as the shape of the chart depends entirely on the subject matter in front of the camera being given a correct exposure. Using the camera histogram as an aid to correct exposure is covered in more detail on pages 72–75.

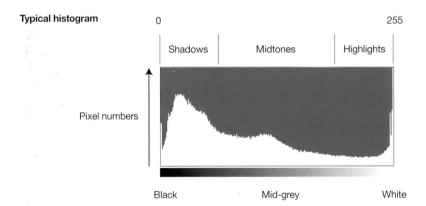

Typical histogram

0                                                            255

Shadows | Midtones | Highlights

Pixel numbers

Black                        Mid-grey                        White

### Histograms of simple subjects (facing page)

Black pebbles on black surface; grey pebbles on mid-grey surface; white pebbles on white surface; black and white pebbles (high contrast); pebbles of all shades of grey (average subject).

**Photographer:** David G Präkel.

**Technical summary:** Nikon D200 60mm f/2.8D AF Micro, Bowens Esprit 500 flash with umbrella, all f/25, ISO 200.

**histogram** a bar chart of frequency distribution showing how many pixels are found at each brightness level

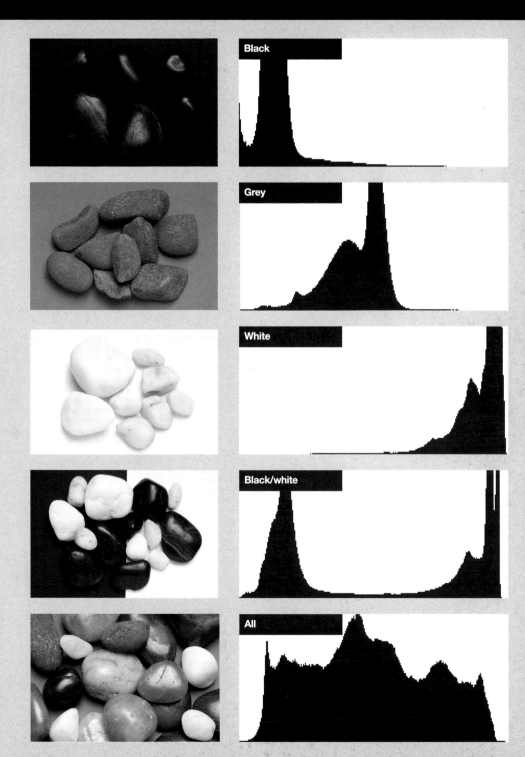

Black

Grey

White

Black/white

All

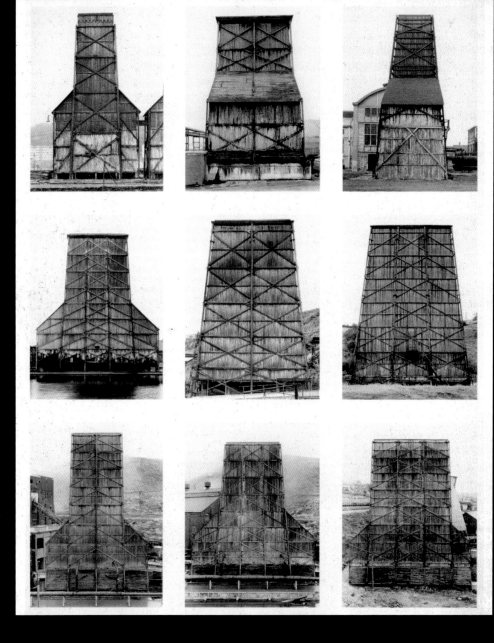

Photography was long considered a charlatan art. To even be considered art, photography had to concern itself with the traditions of fine art. It is Steiglitz, with his Photo-Secession group, who is widely credited with achieving the acceptance of photography as an independent form of visual expression alongside, though not part of, mainstream art. Only slowly did the art establishment accept the 'straight' images of photographers such as Henri Cartier-Bresson and Paul Strand. It is somewhat ironic that as the art mainstream slowly reached out to include black-and-white photography, the postmodern movement was already embracing cheaply and readily available colour imagery.

Though colour imaging techniques were available to early twentieth-century photographers, they were often complex processes giving indifferent results and were never widely adopted. It was not until the late 1940s that members of the public began to use colour film and it was not until the mid-1970s – with William Eggleston's groundbreaking 1976 exhibition of colour prints at the New York Museum of Modern Art – that the art world finally recognised colour photography as a legitimate art medium.

Why did black and white hang on as the principal art photography medium for so long? There are two valid reasons. The first is that colour photographs were not thought of as sufficiently long-lasting to have the permanence and gravitas of a silver halide print. Secondly, colour was thought of as a compositional distraction. This reinforced the view of black-and-white photography as an aesthetic medium.

Every photographic image – colour or black and white – has a degree of abstraction. All photographs take the three dimensions of the physical world and represent them within the frame of the image on a two-dimensional sheet of paper. The second degree of abstraction is the suspension of time. The image can fractionate time or depict a specific duration. Then comes the third degree of abstraction, unique to monochrome images. Black-and-white photographs are representative and do not attempt to recreate the look of the real world. This is their artistic power.

### 'So often color gets caught up in color, and it becomes merely decorative.'
*Mary Ellen Mark (American social photojournalist)*

### Kühltürme (facing page)
Individually, these formalist black-and-white images of industrial buildings are objective, almost of scientific record, but their collection into a typology (a systematic classification of types) has a postmodern sensibility. The Bechers' work has had a wide influence beyond photography on minimalist and conceptual art.

**Photographers:** Bernd and Hilla Becher.

**Technical summary:** None supplied.

## Learning to 'see' in black and white

As part of the process of abstraction, landscape artists of the past used reflecting surfaces made from obsidian – a black volcanic glass. Unlike metallic mirrors these obsidian 'mirrors' removed colour from the reflected scene, leaving just line and shape. (They are more commonly found today in occult rather than art shops where they are sold as so-called 'scrying' mirrors. A piece of shiny black plastic would be a cheaper substitute for experimenting.) Certain photographers use a similar device: the monochromatic viewing filter. This comprises a Kodak Wratten 90 filter or equivalent in a mount and lets you view the direct, rather than reflected, scene. These have to be used briefly so the eye does not reintroduce colour as it readjusts.

Photographers talk about being able to 'see' in black and white rather than just imagining or visualising the scene. Closing one eye and screwing up the eyelids of the other is a useful trick. Not only does this remove stereo vision to produce a flatter, more two-dimensional representation but it also inhibits colour vision and helps give a feel for the contrast in a scene. Learning to 'see' in black and white is also a question of learning how colour is represented by grey tones and becoming more aware of the formal elements of composition that relate to black and white: line, shape, form, texture and pattern. Contrast has to be found in a different way without colour – shade and shape play a more important role.

One of the threats posed by digital imaging is that it is a colour capture technology. The creation of black-and-white images nowadays is very much a post-production event – a 'cool' alternative look for a colour original. This means that photographers are at risk of losing what Ansel Adams called **previsualisation**, in other words the art of picturing the finished black-and-white print at the time you take the photograph. Not only does this help you get the best out of any chosen scene in terms of shadow and highlight capture but it goes further than that. Having a black-and-white-only medium in your camera means you become more responsive to tone, texture and shape – the very aspects that make monochrome photography the great expressive medium that it is. With a colour digital camera around your neck anything goes. There is always the opportunity to be 'distracted' by colour.

**previsualisation** imagining how a finished image will look before the exposure is made

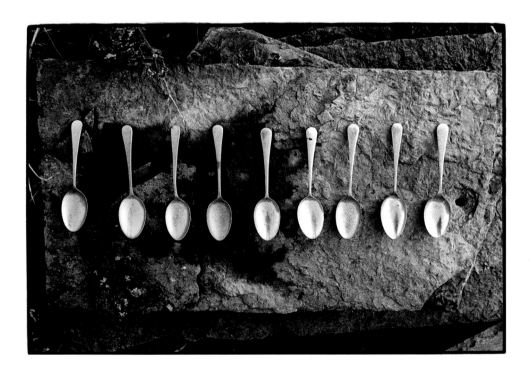

**Spoons (above)**

Where colour would distract – this deadpan monochrome study begins to explore the comic in its novel juxtaposition of cutlery and a large stone roofing slate.

**Photographer:** Steve Macleod.

**Technical summary:** None supplied.

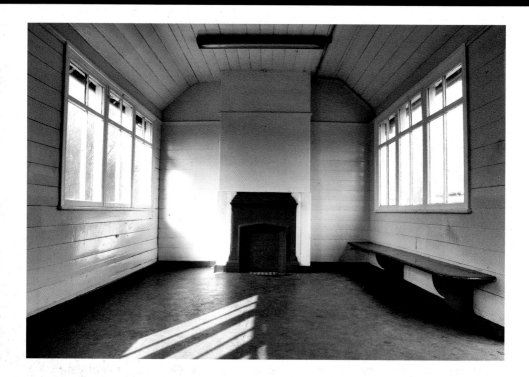

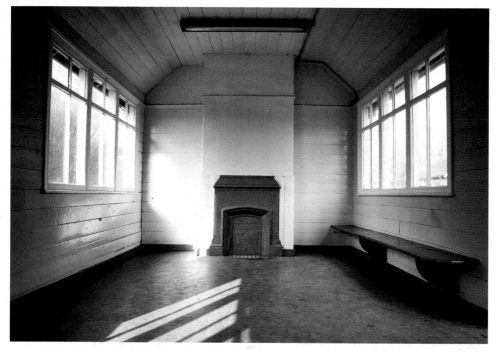

# Previsualisation and composition

The great photographic technician and landscape artist, Ansel Adams, made the word 'previsualisation' popular and it has stuck in the photographic vocabulary ever since (later, he would admit that the prefix was redundant and that simple 'visualisation' was sufficient to describe the process). What Adams meant was that to create a fine black-and-white print you need to 'see' the finished tonal range in your mind's eye. You should be able to correctly expose and plan the development of the material in your camera at the time you make the photograph. His was a technical argument. There are, however, equally strong grounds for (pre)visualisation in the artistic sense – to learn to see how the real world will look in black and white.

Without colour, there is only a tonal palette to choose from. Artists have learned to explore similar ground using just pencil or charcoals, a single paint colour or pastels, as in chiaroscuro. True chiaroscuro drawing is on midtoned paper where the artist works towards the light with white paint and towards the dark with black. In a broader sense, the term is used to describe designing with light and dark – the very process that the monochrome photographer seeks to perfect. This requires sensitivity to the balance, or intentional imbalance, between the light and dark components of an image. Lighting, filtration and exposure can then be used to rearrange or manipulate these tones.

Black and white makes colour harmony, contrasting colours and all the psychology of colour associations redundant. It is a purer medium that deals with just the bare bones of composition. Immediately identifiable as such, black-and-white imagery of all qualities can masquerade behind its iconic monochrome 'look'. Because of this, it needs a strength and certainty of approach from the photographer to produce good results. Converting a weak, existing colour image into black and white produces only a weak black-and-white image. Simply removing the colour brings nothing new to the table. Concept and content have to be there from the start.

**Fireplace, NE Railway waiting room (facing page)**
This colour image is a study in the flat areas of colour – grey/blue, red and yellow. The compositional emphasis is completely redirected to the light streaming through the windows when the image is reinterpreted in black and white.

**Photographer:** David G Präkel.

**Technical summary:** Nikon D200 18–200mm f/3.5-5.6G VR AF-S DX IF-ED Zoom-Nikkor at 18mm 1/180 sec at f/7.1 ISO 200. Converted to black and white in Adobe Lightroom.

## The great themes

### People

We have an immediate interest in the faces of family and friends, those we know. Through continual exposure to images of their faces in the media we also think we know so-called 'celebrities'. Their faces can become as familiar as our own. However, there is also an undeniable human interest in the anonymous faces we see in so many photographs. The arrangement of the human face is one of the first patterns our brains learn to recognise; without a mother's face to focus on, we would be without food, security, warmth and love. It is because of this that the human face holds so much fascination. In a still image we can also gaze as long as we like without fear – the returned gaze is forever the same.

Formal black-and-white portraiture seems to demand and promote an even deeper observation of the individual. Black-and-white portraiture has a rather levelling effect. It effectively removes people from their time and their surroundings. Without the distractions of skin tones and coloured clothing, the sitter's soul seems stripped bare. While in one sense black and white has this unerring ability to get beneath the skin, its literal depiction of the sitter's skin gives even more information on their character and disposition. It is true that without colour clues we pay more attention to texture. With the skin of the face, texture means the 'worry lines' and 'laughter lines', the physical representation of the character of the person. Black and white shows these features well.

The black-and-white fine print can be more subject to the photographer's personal taste and can therefore be used as part of the interpretative art. With black and white it is also more likely that the photographer will have some direct control over the final print or even produce the print themselves. Subtle adjustments of tonality and tonal balance can shift the mood of a picture and underline a characteristic mood in the sitter.

### Migrant Mother (Nipomo, California, 1936) (facing page)

This is one of the world's most reproduced photographs. It is an iconic image showing an individual woman but depicting the hunger and privations of thousands. This print is on the original record card for the Resettlement Administration (later the Farm Security Administration), showing the power and strength of Lange's image even in this bureaucratic setting. Lange, an expressive documentary photographer, took five earlier images, each time getting closer to her subject both physically and metaphorically.

**Photographer:** Dorothea Lange.

**Technical summary:** 4 x 5in Graflex camera.

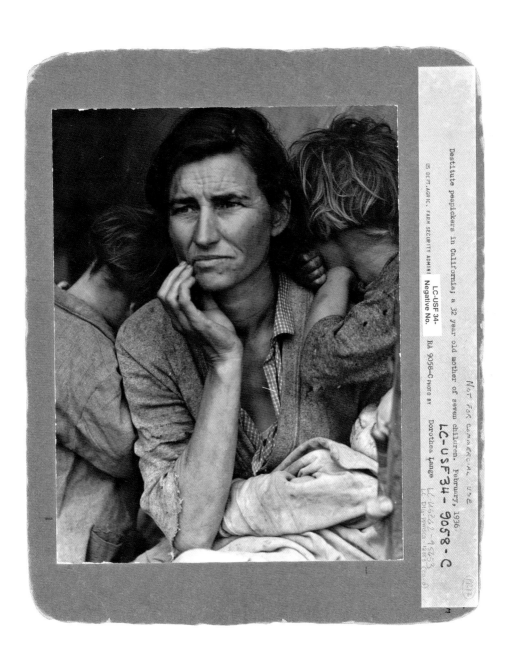

Destitute peapickers in California; a 32 year old mother of seven children. February, 1936.

NOT FOR COMMERCIAL USE

US DEPT.AGRIC. FARM SECURITY ADMIN

LC-USF 34-
Negative No.

Ed. 9058-C PHOTO BY

Dorothea Lange

LC-USF34- 9058-C

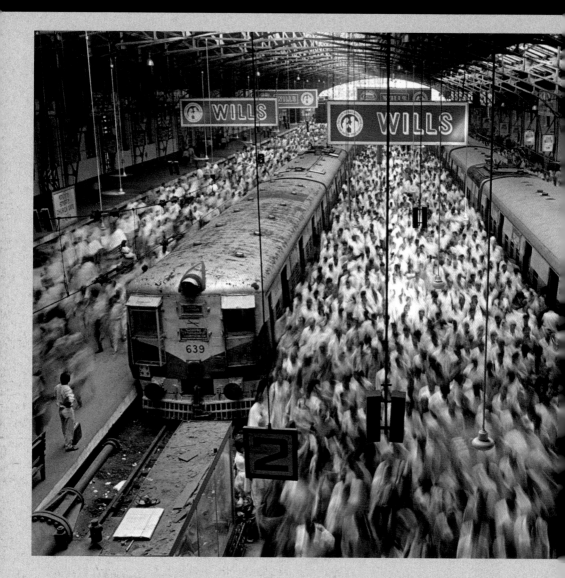

**Church Gate terminus, Bombay (above)**
A wide-angle view taken with a long shutter speed shows the rush of the Indian commuter
crowd – a magical evocation of life in any city.

**Photographer:** Sebastião Salgado.

**Technical summary:** None supplied.

## The city

Black-and-white film was the only medium of record as the great commercial centres of America and Europe developed. As cities grew upwards, packing more people and activity into ever-more expensive real estate, the urban landscape also changed. City streets became deeper, shadowy man-made canyons with side streets and alleys that introduced shafts of sidelighting to produce scenes of stark high contrast. Black and white serves to enhance the compositional elements of line and strong graphic shapes found in city structures. Its wide **latitude** captures and relishes the bursts of blinding light and deep shadows of a city.

The dynamic complexity of the urban scene is also well served by the medium of black-and-white photography. The city is the province of the wide-angle and short telephoto lenses. Wide-angle lenses give an all-involving look to the bustle of the city and its people. In street markets and crowds the wide-angle lens must be used close-in to create involving images that put the viewer into the thick of the action.

When working with wide-angle lenses in city streets it is important to remember that the low viewpoint, relative to the tall buildings, will produce converging verticals in the image. Rather than fight this, the best images instead incorporate dramatically converging verticals. Photographers can build this into their style, emphasising the dynamic strength of diagonal lines. The diminution of the upper parts of the buildings enhances the sense of the individual as just a small cog in the big city machine.

Shorter focal length telephoto lenses can be used to gently collapse street perspectives or to select sections of interest from the overall view. The short telephoto is a great tool for reducing image clutter and cropping in. It is the choice of the observant bystander looking in on the dramas of city life found on its pavements and in its squares.

latitude degree of over- and underexposure film or digital sensor can accommodate and still provide an acceptable image

**Still life**

Though at first sight they would seem unlikely source material – a single beach pebble, an egg, a feather or seashell – some of the simplest forms and objects have produced the most striking black-and-white still life photography. Drawing academies would teach beginners to capture the light and shade on simple geometric forms using wooden cones, blocks and spheres. Photographers too find the same exercise useful to develop their awareness of how light interacts with surface and solid forms. Hiroshi Sugimoto's recent photographs of the solid geometric forms created in the nineteenth century to help students understand complex abstract mathematical functions are in the great tradition of black-and-white still life photography (see pages 8–9).

Though the subject matter is simple, it demands the greatest care and close observation of lighting. This reveals not only the form, through shadow and highlights (which have to fall within the range that can be captured by the medium) but also reveals the texture. Some photographers, such as Edward Weston, have revelled in the lit qualities of simple objects; the nautilus shell and pepper (capsicum) were some of Weston's favourites. The sensitivities developed through the manipulation of light and positioning of form in these images is evident in his depiction of the human body.

Paul Outerbridge Jr's exquisite 1931 still life exploration of tone and form, rather knowingly entitled *Consciousness*, required only a plank, two eggs and a cone for the image. Though better known for his commercial colour photography, Outerbridge's early black-and-white images show a great strength through simplicity with such uncomplicated subject matter as a detached shirt collar or a milk bottle, bowl, eggs and a spoon.

Albert Renger-Patsch's name is also associated with this type of photography. Described as 'new objectivity', his work aligned with the Neue Sachlichkeit movement in German art from the 1920s and '30s. Renger-Patsch excelled with that most difficult of materials to photograph well – glass. His 1928 book *The World is Beautiful* seeks out the strength and simplicity of form in everyday (even mass-produced) objects, using the almost scientific abstraction of crisply focused, full tonal range, close-up, black-and-white photographs.

Peter Keetman (1916–2005) took still life sensibilities out of the studio and into the real world. His visit in 1953 to the re-established Volkswagen factory treated the subject matter in an impactful, abstract manner. Stacks of pressed steel car wings on the factory floor are observed with the same eye as a studio still life photographer would view a seashell. Keetman, like Renger-Patsch, combined the technical finesse of the scientific record photograph with the feel of an abstract painting.

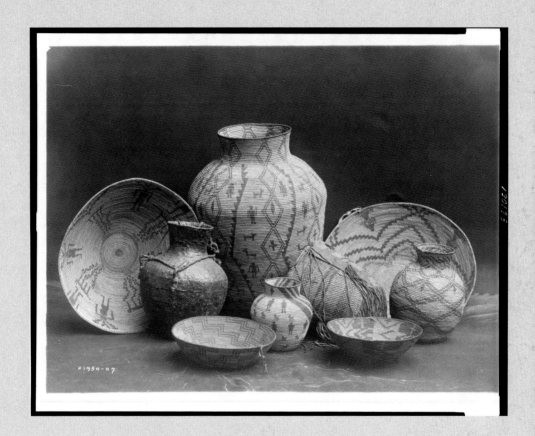

## Apache still life (above)

Curtis travelled the American West in the early decades of the twentieth century, recording the vanishing traditions and lives of the North American Indians. This beautiful, simply lit still life shows an arrangement of nine woven bowls, baskets and jars – a black-and-white study of pattern, textures, tone and form.

**Photographer:** Edward S Curtis.

**Technical summary:** None supplied.

### Landscape

In landscapes, as in still life, the manner in which light interacts with form, surface and texture has become a legitimate body of artistic exploration for the black-and-white photographer. Unlike still life, however, the photographer is rarely in control of the light. Working with still life objects in the studio is a fine apprenticeship for the landscape photographer. It develops a sensitivity to the fall of light and the way in which the tones that are produced show textures and volume. There of course has to be more to composition than the exploration of tone and form unless the images are to be merely pictorial and a study in aesthetics. There has to be so much more to landscape than this. There is little to commend a glorious monochromatic landscape image with little or no meaning or emotional content.

Whatever their motivation, landscape photographers working in black and white need to be critically aware of the light. Patience of course plays its part. As the day or season changes, the light will move across the landscape to reveal some features and suppress others in shadow. It is the clear observation of these changes, their potential and the choice of the precise moment to make an exposure that marks out the great landscape photographer.

Technically, landscape offers many challenges. This is especially true when it comes to capturing a subject brightness range that must include both shadow detail and detail in the clouds. Careful choice and use of graduated filters and latterly the use of high-dynamic-range digital composite images is important in capturing the essence of what our eyes see unaided.

The best technical pictures must have something more. This is perhaps best described as their having a sense of place. There is something unique, something that creates a singular emotion in certain places. The mood of monochrome photography can be allied to this to produce images with a compelling strength of feeling. Being master of the whole black-and-white process – from choice of film and exposure through film development, to the choice of paper and printing – gives photographers the unique opportunity to amplify the mood within their landscape images.

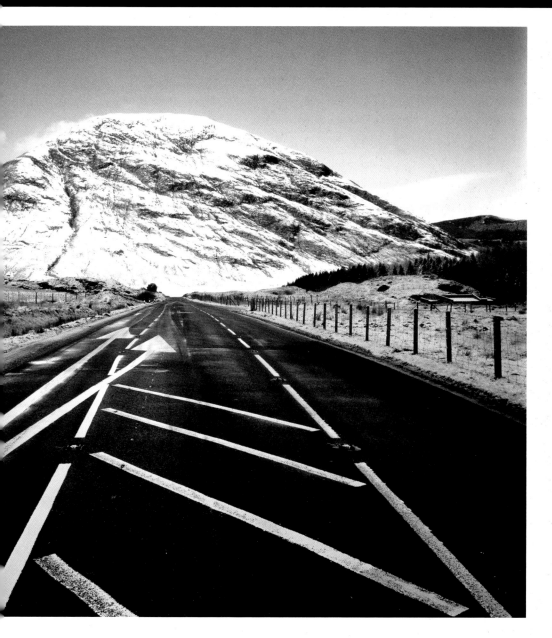

**Meall Mòr, Glencoe 1988 (above)**

Godwin uses the juxtaposition of the road markings and powerful landscape forms to
make a political point about land management and access rights in this image, first published
in her book *Our Forbidden Land*. Black and white kicks home her message.

**Photographer:** Fay Godwin.

**Technical summary:** None supplied.

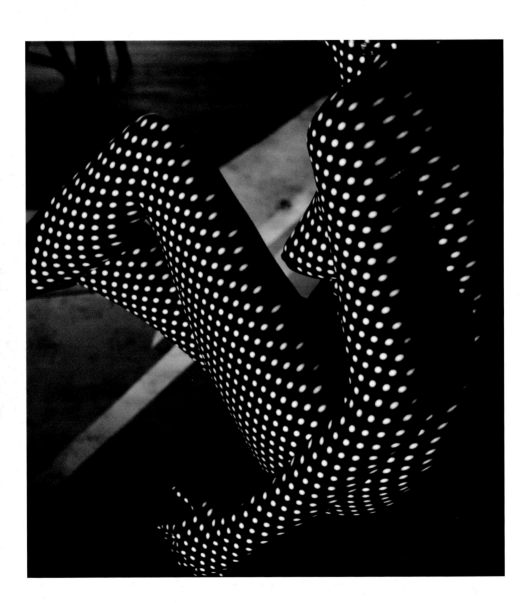

## The body

Many of the greatest nude images (depicting both male and female) are of just the human torso. Images are often depersonalised by cropping. It is part of the difference between naked and nude. Because expression and individuality are removed, the classic nude study is also de-eroticised. There is a complete change in the viewer's reaction if the head and face are not seen. This degree of abstraction, of producing an iconic image, can only be helped by the medium of black and white. Removing skin colour leaves only tone; simple and neutral. The body is now depicted in terms of its forms and volumes by subtle changes in grey tones. As tonal information in a black-and-white image is carried by the fineness and abundance of grain (here we are talking about film only), it stands to reason that fine-grained, large-format negatives will be the medium of choice.

When dealing with shape and form it is wise to become aware of the shapes 'left behind' by the body. The negative shapes in other words. Because of our familiarity with the form of the human body, these negative shapes can have a strong overall effect on a final reading of the image.

High-speed, grainy, miniature-format films can have a part to play in depicting the human form but their use introduces an entirely different dimension to the images. Available light, high-grain images can be highly eroticised and often bring a powerful narrative to the image. The combined use of wide-angle lenses and close viewpoints can also produce a personalisation and intimacy that is sometimes intentionally unsettling to the viewer. The elongation and distortion of body forms also adds a degree of alienation to such images.

The edginess that this style of photography brings to images of the human body is in strong contrast to the refined and controlled black-and-white nude that is a study in aesthetics. One is a refined abstracted study that has a good deal in common with sculptural still life images and landscapes. It is done by the craftsman photographers with large, slow-to-operate cameras. The other is immediate and intimate. The viewer, knowing it is produced with a hand-held camera, is implicated by the photographer – complicit in sharing a voyeuristic viewpoint.

**Studio couch, 1956 (light and shadow) (facing page)**

In addition to the abstraction of the black-and-white medium, Fonssagrives uses only points of light to reveal the form of the body in its distortion of their repeating pattern.

**Photographer:** Fernand Fonssagrives.

**Technical summary:** None supplied.

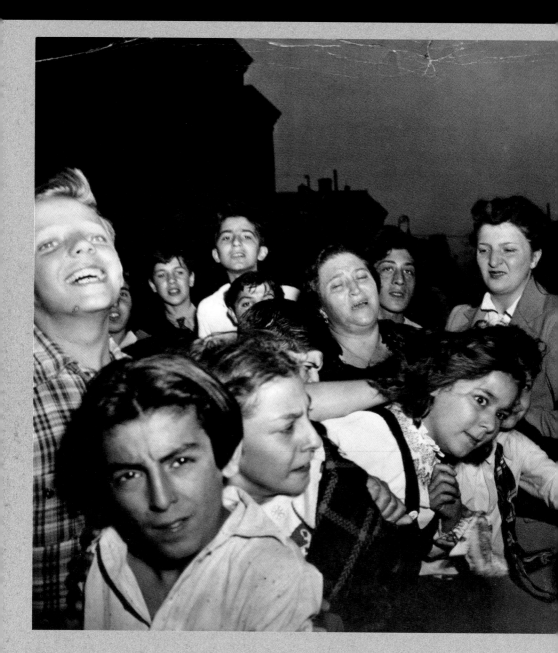

**Their First Murder (above)**
Weegee turns his camera around from the murder scene to record the crowd of onlookers and the range of their reactions – for him the 'real' event.

**Photographer:** Weegee (Arthur Fellig). (Reproduced courtesy of Getty Images.)

**Technical summary:** None supplied.

## The event

A colour image could only have been taken in the last six decades. In contrast, a black-and-white image could date from any time since the birth of photography in the late 1830s. There is almost a 'suspicion' attached to colour images of historical events. Images of the Second World War (1939–45) are usually in black and white despite colour film material having been available, albeit in small quantities, to both sides during that conflict. The colour images that do exist have a remarkable effect of shifting historical perspective and viewpoint. Though the Americans did fairly extensively record the end of the Pacific War in colour, rare surviving colour images from the European battlefields or from the rise of Nazism are considered sufficiently interesting to have had documentary film made and books published about them.

A change began with the war in Vietnam, although the iconic pictures from that conflict still tend to be those in black and white. Only subsequent conflicts have been recorded almost exclusively in colour and even then it is the moving image that remains in the mind, not the still picture.

When it comes to the serious business of recording a historical event it seems that no other medium will do. Only black and white has sufficient 'dignity'. Because this feeling of sober judgement and finality is attributed to the black-and-white photograph, any image taken that depicts an event or which is merely a record of something happening, gains this import and authority by being taken in black and white.

Black-and-white images that are clearly taken with flash or that use grainy film have a quality that says 'extra effort was expended by the photographer in bringing you this picture'. The photographer was clearly not a passive bystander, but actively participated in the event on our behalf to capture an image, possibly with some difficulty or at some additional cost. The very essence of the black-and-white image is that it 'bears witness'.

**Photo essay/social documentary**

Black and white brings a historical 'weight' and apparent objectivity, while colour has an immediacy that is not always appropriate to the subject. The implied craft aspect of black-and-white images gives them import, where colour images could be seen as having a mass-market label. Colour images are often levelled at popular taste, maybe even dumbed-down for a general public. The black-and-white image has connotations of being a considered aesthetic, of requiring a little more effort to understand and with a rigour and intellectual weight. Black and white's extra degree of abstraction can be read as the visual equivalent of saying: 'Let's step back here and take a considered look at things.' Put these attributes into the context of story-telling and one of the most powerful photographic mediums is born: the photographic social documentary essay.

Just like a written essay, the photo essay is expected to have a formal structure. Where a photojournalist will encapsulate the story in a single powerful image, the documentary photographer will produce a series of thematically connected images. Though a sequence is imposed on the images, this may not literally be the temporal order in which the images were taken. If commissioned, the commissioning picture editor may well expect to see a clear structure. Though it is possible to describe the required images in technical language (wide, establishing shot; close-ups of activity, a decisive event or moment, portraits (headshots), concluding image and so on), it is easier and better to recommend that you look at the work of the master photo essayist, W. Eugene Smith. The monograph *Let Truth Be The Prejudice* reprints Smith's exemplary *Life* magazine essays *Country Doctor* and *Nurse Midwife*.

Whereas a photo story will need a linking written narrative, the photo essay will have clearly connected images that can stand individually without textual explanation. However, every picture will need a clear caption and often the hardest part of creating the photo essay is to stop shooting and start writing down answers to the 'who, what, why, where and when' questions of the print journalist.

A photo essay is a considered body of work where the whole is greater than the sum of the parts. It may be the outcome of a self-initiated project or of a commission. The success will depend a lot on the amount of background research done to support the photographic endeavour – the photo essay is not for the lazy. Nor will success be found by having a preconceived idea, as things will be revealed in the process of uncovering the story and an entirely unexpected angle may emerge. Where the news photographer goes to cover a story, the social documentary photographer goes to uncover a story. It will be personal.

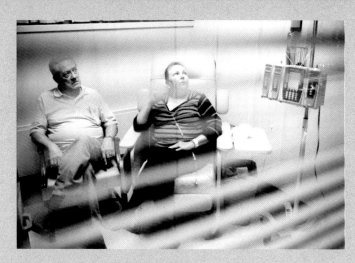

**TennCare; Tenessee health care crisis (above)**
Nashville, Tennessee 2005: Shirley Ellis, 59, has been battling ovarian cancer for two years.
She was recently dropped from TennCare coverage and now faces losing her chemotherapy
treatment, which costs $8000 a month.
**Photographer:** Ed Kashi.
**Technical summary:** None supplied.

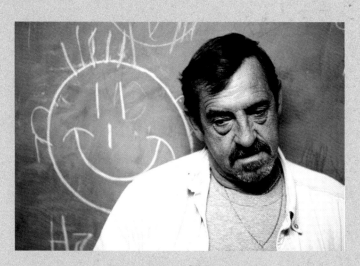

**TennCare; Tenessee Health care crisis (above)**
Nashville, Tennessee 2005: Troy Reed, 54, has heart disease and is uninsurable. He has
never qualified for TennCare and has suffered a massive heart attack and had a quintuple heart
bypass. He comes to the North Terrace Medical Clinic for free medication and check-ups.
**Photographer:** Ed Kashi.
**Technical summary:** None supplied.

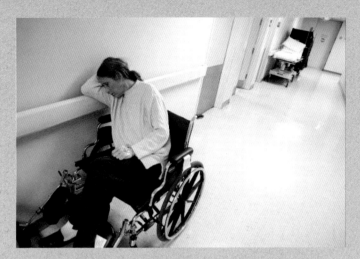

**TennCare; Tenessee Health care crisis (above)**
Dania Tawater waits for a CAT scan. Tawater, 45, needs a liver transplant due to cirrhosis of the liver and hepititis C.

**Photographer:** Ed Kashi.

**Technical summary:** None supplied.

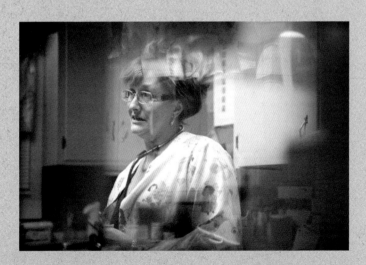

**TennCare; Tenessee Health care crisis (above)**
Nashville, Tennessee 2005: Nurse Pat Burks of the North Terrace Medical Clinic in rural Tennessee serves mainly indigent, uninsured people. She opened the clinic in 1993.

**Photographer:** Ed Kashi.

**Technical summary:** None supplied.

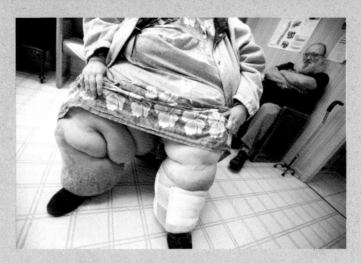

**TennCare; Tenessee Health care crisis (above)**
Nashville, Tennessee 2005: Debra Prince, 52, suffers from elephantiasis and other chronic diseases. She has been kicked off TennCare, Tennessee's version of Medicaid.
**Photographer:** Ed Kashi.
**Technical summary:** None supplied.

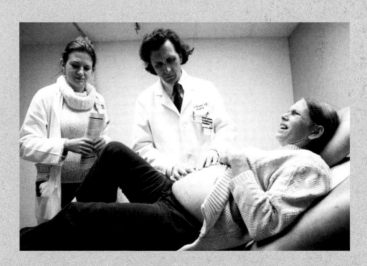

**TennCare; Tenessee Health care crisis (above)**
Nashville, Tennessee 2005: Dania Tawater visits Vanderbilt Hospital's transplant clinic to get a check-up by her liver transplant doctor. Tawater was about to have a liver transplant but due to being dropped from TennCare and without insurance, she was denied the liver. She was given four months to live unless another liver was found.
**Photographer:** Ed Kashi.
**Technical summary:** None supplied.

## Personal vision

Conventional wet film colour photography can be a frustrating and expensive enterprise for the individual. In contrast, the low cost and simplicity of black-and-white film development gives photographers a great opportunity to experiment and develop their own style within the medium. Experimentation with technique rapidly turns to experiment with content. Ralph Eugene Meatyard's images from his series, *The Family Album of Lucybell Crater*, would never have had the same impact if he had not been in total control of the creative process. Some photographers even find the idea of their films being processed by others difficult to accept and would never send a film away to a lab for printing.

Though primarily seen as a master technician, Ansel Adams was of the opinion that, 'the artist must feel free to select his rendering of **tonality** as he is to express any other aspect of the subject'. Adams makes a strong point that is at the heart of photography. Like no other art form, photography relies on intervention of an imaging technology in the realisation of the personal vision. Without some understanding of the technical processes involved, mastery is impossible and the outcomes will be serendipitous (though there is no artistic harm in calling on fate to play a part in the creative process, it is often a cruel and uncooperative partner!). Without personal experimentation and exploration of the medium, it would be impossible for the individual to see a range of results and to produce their personal choice and style from those possibilities.

This experimentation need not take the form of a structured scientific study, but enough records must be made to be able at least to repeat the process successfully. Beyond the technical exploration, there is the exploration of subject matter. How does this subject stack up to being photographed? At its core this is what Gary Winogrand was explaining when asked the often-posed question, why do you photograph? His answer was to explain that his interest lay in seeing what things looked like when he photographed them. That curiosity is really what 'personal vision' is all about.

**tonality** quality of tone or contrast

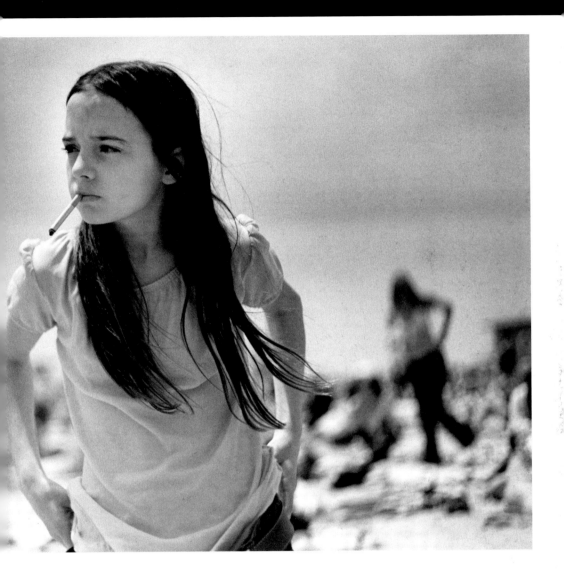

**Priscilla (above)**

Szabo documented his teenage students throughout the 1970s and 1980s. His approach is simple and uncritical, capturing the ambiguities and transitions of the formative years. Black and white remains a vital and expressive medium for this type of personal investigation.

**Photographer:** Joseph Szabo.

**Technical summary:** None supplied.

## Older cameras/lenses for a unique look

Digital black-and-white editing opens up immense possibilities. You can produce images that are not limited by the look of traditional darkroom techniques. However, when it comes to digital capture there are limitations to the look of the black-and-white images produced. Modern digital cameras are fitted with quality lenses that produce great depth of field, low distortion and good resolution. There is also inherently much greater depth of field with smaller image formats. Sometimes this is not what you want. Modern lenses with a multi-blade iris can produce angular geometric highlights that look quite unlike 'older' lenses. Though these cameras and old style lenses give pleasing results with colour, their real 'look' is the one combined with the purity and timelessness of black and white.

A photographer can intentionally recreate an 'old-fashioned' look, but it is easiest using 'old-fashioned' equipment and materials. The flare and softness of an old lens gives a distinct quality that cannot readily be imitated by digital means. A larger-format negative will mean a shallow depth of field even with the lens stopped down. It is easy to expose film in an old camera and later scan the film. Being dogmatic about film or digital is not productive. Blending the technologies for their specific strengths has produced some of the finest images. To get the best of both worlds, an old style silver-rich film (such as one that is not a modern tabular grain or **chromogenic** black-and-white film), exposed with an old-fashioned, soft-focus portrait lens can be scanned, enhanced and printed digitally. Many of the smaller film companies still producing film in Eastern Europe on older machinery make film that has rich blacks with plenty of shadow detail, attractive grain and creamy smooth tones.

Many older cameras have lenses with unusual, often distinctive qualities. Polaroid picture roll cameras of the 1948–1963 era (like this Model 110a) are commonly cut about to take Polaroid pack film (picture roll was discontinued in the mid-1980s). More adventurous 'hackers' modify these cameras for roll film to produce oddities such as 6 x 10cm panoramics. They even fit 5 x 4in film backs to a camera designed to cover 3.25 x 4.25in, the resulting light fall-off (**vignetting**) just adding to the 'look'.

**chromogenic** photographic process using chemical couplers to create coloured or black-and-white dye images from the original silver image that they replace. Black-and-white film that is developed in colour chemistry

**vignetting** light fall-off towards the edges of an image – sometimes a lens fault, sometimes done to 'age' the look of an image by edge burning

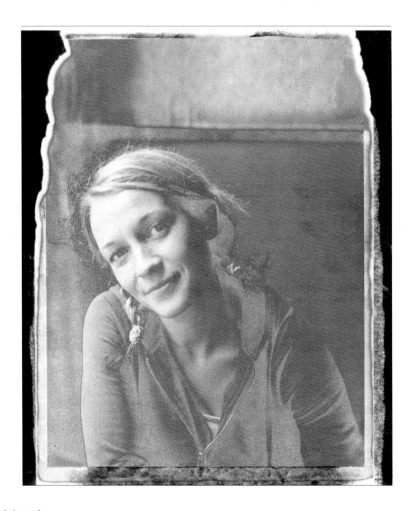

## Lene (above)

Outdated material, an older camera converted to use this material and modern digital scanning combine to produce a unique portrait.

**Photographer:** Gerald Chors.

**Technical summary:** Polaroid 110a picture roll camera converted to Polaroid pack film by Four Designs Company with 127mm, f/4.7, 4-element Rodenstock Ysarex lens. Scanned positive image from 667 pack film paper negative.

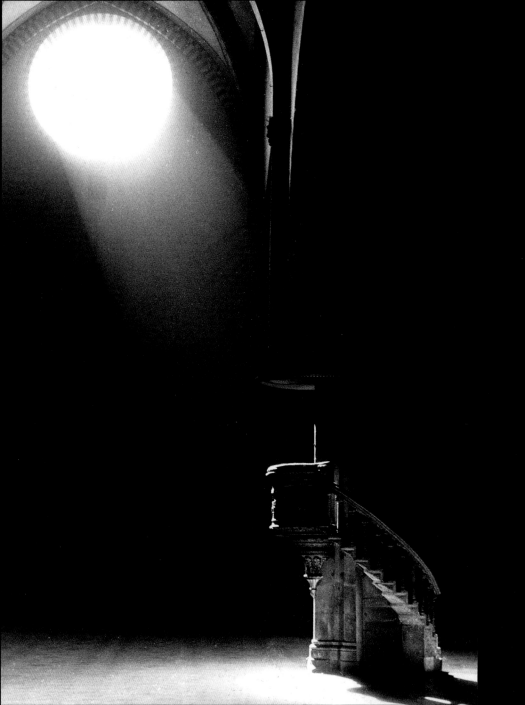

In black-and-white photography, light is the only ingredient you have to play with. Without colour and its associations and meanings, you have to work with the presence and absence of light alone. The light determines the contrast and overall mood of your image. The way it creates harsh shadows and highlights or is dispersed softly throughout the image, the direction from which it comes to light your subject – these are the raw ingredients of the fine black-and-white photograph.

There needs to be both an aesthetic awareness and a technical confidence when dealing with light for black-and-white photography. This chapter looks at not only the quality and direction of light, which both play the greater part in establishing the mood of the image, but also at the subject brightness range and how it is derived from the contrast of the subject itself and of the light that falls across it.

Knowing how to choose and use an appropriate light meter is essential for being able to achieve the best exposure. This is necessary to fully exploit the available dynamic range of either film or digital. Many fine images have been lost simply through poor exposure. It is important to retain full detail in the shadows and not to lose the brightest highlight details to the white of the paper on which the image is printed.

This chapter also looks at how skewing the tones in an image towards the extremes – either the dark or the light ends of the tonal spectrum – can dramatically change the mood of an image. This is described as low- and high-key imagery. 'Key' refers to the overall tonal quality of the finished image in this context.

A concluding section looks at the use of infrared film and digital techniques used to create an entirely unimagined look.

**'I always go for black-and-white. It has a more dream-like quality. There's something that's more unreal about it. It's more graphic and timeless. I just prefer it.'**
*Ellen von Unwerth (Fashion and advertising photographer)*

**Untitled (facing page)**
Light itself becomes the subject of this black-and-white photograph of a church interior, creating a dramatic sense of anticipation and focus.
**Photographer:** Catherine Forrest.
**Technical summary:** None supplied.

## Quality

The quality of light is something that needs to be recognised, even if a photographer is not going to control or change it. In the studio, photographers have the opportunity to modify and shape the light. In the real world it is important to recognise and make the best of the quality of light in any given photographic situation.

Light from a point source (a naked flame or bulb) will cast shadows away from itself in all directions. It will give harsh highlights and strong shadows. Because of the circumstances in which we encounter this type of light, it has become iconic – visual shorthand in other words – for something that is perhaps a little scary or alienating. Light from a point source dies away very rapidly. Two strides away from a point source the light has one quarter its power; take another two strides away and the light falls to one sixteenth its power. (This is the inverse square law at work. Power is equal to one over the square of the distance.) This law explains why the light from a campfire seems to die away so quickly away from the flames.

The only point source not subject to the inverse square law is the sun itself. This is because any distance we move on earth is trivial to the distance the earth is from the sun. In a clear sky the sun acts as a point source and creates strong shadows. Portrait photographers traditionally favour the light from the northern sky (in the northern hemisphere) without direct sunlight, as this gives strong but diffuse lighting.

It is a myth that candlelight gives a soft romantic quality – light from a single candle actually casts hard shadows as it is a point source – it is light from many candles that produces a warm diffuse glow. Light from a truly diffuse source has quite a different quality to it. A subject in a room lit with candles not only receives direct light from the individual candles but also the diffuse light reflected from the walls and ceiling of the room.

**Sticks on a windowsill (facing page)**
A change in the quality of light can alter the look of an image dramatically even though the direction of the light remains the same. Harsh point-source lighting creates strong textures and long shadows (top) – a simple white cloth was used to diffuse the light (bottom).
**Photographer:** David G Präkel.
**Technical summary:** Nikon D100, 60mm f/2.8D AF Micro.

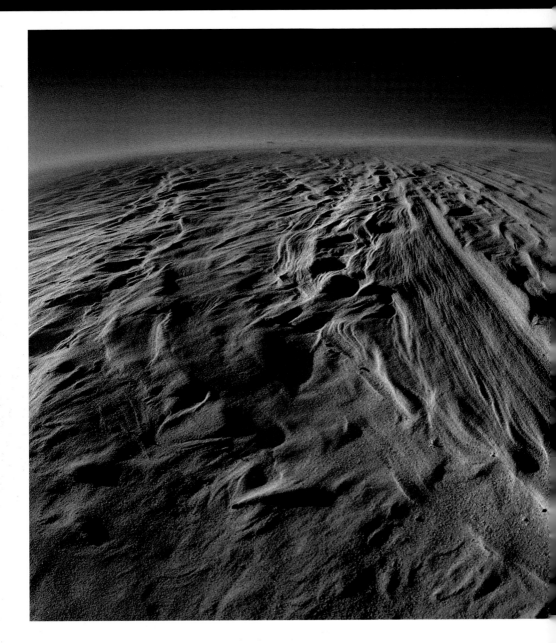

**Dune #18 (above)**

The direction and low angle of the light is critical in revealing the texture of the sands which itself becomes the subject of this image.

**Photographer:** Nana Sousa Dias.

**Technical summary:** None supplied.

# Direction

From our earliest days as babies, sight and touch are closely related. Our visual systems look at objects held in the hands and correlate highlights and shadows with the source of light and the three-dimensional physical presence of that object. When we learn to draw we start with outlines but quickly learn to understand three-dimensional shapes drawn on a flat paper surface. The artist uses the artificial highlights of untouched paper and pencil cross-hatching to show shadows, using these tonal values to create and model a three-dimensional world from the two dimensions of the paper surface. Photographers need to understand how shading, highlights and shadows create the appearance of the solid form on the flat sheet of photographic paper.

The direction from which the light falls plays a great part in establishing form. It can also affect the emotional mood of an image. The sun lights our outdoor world. In the temperate latitudes of the globe – between the tropics and the polar regions – the sun's elevation varies, roughly between 20 and 60 degrees above the horizon. Light from this kind of angle has become almost a cultural expectation, while light from above is associated with exoticism and equatorial heat. Side lighting is seen as autumnal or associated with the very early morning or late evening and the stillness of those times of day. Light from beneath is seen as an inversion of the normal and is associated with the bizarre and alien. When children want to look 'spooky' on Halloween, for instance, they hold a torch under their chins, not above their heads. The angle of elevation of the light source can create different 'readings' of an image and convey different moods, some associated with the time of day or with the time of year.

Light falling directly on to a surface will minimise the appearance of irregularities on the surface. Light falling at a steep angle across the surface – raking light – will highlight the side of each irregularity facing the light and cast a long shadow on the other side. When this effect occurs on the micro scale we describe it as texture. Strong side lighting reveals all the roughness of stone or skin and the grain of wood.

The photographer working in colour can denote or capture evidence of the time of day from the colour temperature of the light. This aspect is denied the photographer working in black and white. Instead, they must rely on clues such as the quality of light and its direction and elevation.

## Subject contrast

Any subject for photography that does not have a flat, neutral tone has some inherent contrast. This is not contrast caused by the highlights and shadows of the illuminating light but the range of tones in the object or scene itself. Subject contrast is the difference between the lightest and darkest tones in an evenly lit subject. White objects reflect back most of the light that falls on them. Black objects, on the other hand, absorb most of the light, reflecting back only a small percentage. So subject contrast can be thought of as the difference between the amounts of light reflected back by the different materials of the subject when the subject is evenly lit.

What comes as a surprise to the black-and-white photographer is how different colours produce grey tones on film – certain shades of red and green can translate to the same grey tone. It is the understanding of how colour maps to neutral tones and how to control this conversion that marks out the good black-and-white photographer.

The basic concept behind all photographic exposure is the idea of halving and doubling. This relationship is commonly known as a stop. Shutter speeds and lens apertures are arranged so that neighbours allow twice as much or half as much light to pass. For example, 1/30th second shutter speed is half as long as 1/15th shutter but twice as long a duration as 1/60th – its neighbours on the shutter speed dial. Aperture works in the same manner. An aperture (on any lens) of f/5.6 lets past twice as much light as an aperture of f/8 but only half as much light as f/4. Manufacturers of modern cameras confuse the issue by using half or one third stop increments.

The light value or exposure value (EV) system is a method of giving exposure settings by means of a single number, instead of using a combination of the traditional aperture (f numbers) and shutter speeds. All combinations of aperture and shutter speeds that give the same exposure are represented by a single number. One EV equals one stop. So if one stop is a halving or doubling of light it can be expressed as a ratio of 2:1, which gives photographers a way of describing the ratio of light to dark – the contrast in other words – where one stop = 2:1, two stops = 4:1, three stops = 8:1, four stops = 16:1, five stops = 32:1, six stops = 64:1, seven stops = 128:1, eight stops = 256:1.

When the ratio between the lightest and the darkest tones in a scene is greater than 32:1 it can be described as high contrast, and when the ratio is 2:1 or less it can be called low contrast. Light meters using the EV number system can therefore be used to 'read contrast', not just give a suggested exposure as an aperture/shutter speed combination.

**English Electric (above)**

A flatly lit subject on an overcast day. The contrast is from the dark and light tones of the subject itself, in this case the rusting white paint and the black paint of the nameplate.

**Photographer:** David G Präkel.

**Technical summary:** Nikon D100, 60mm f/2.8AD AF Micro, 1/250 at f/8, ISO 200.

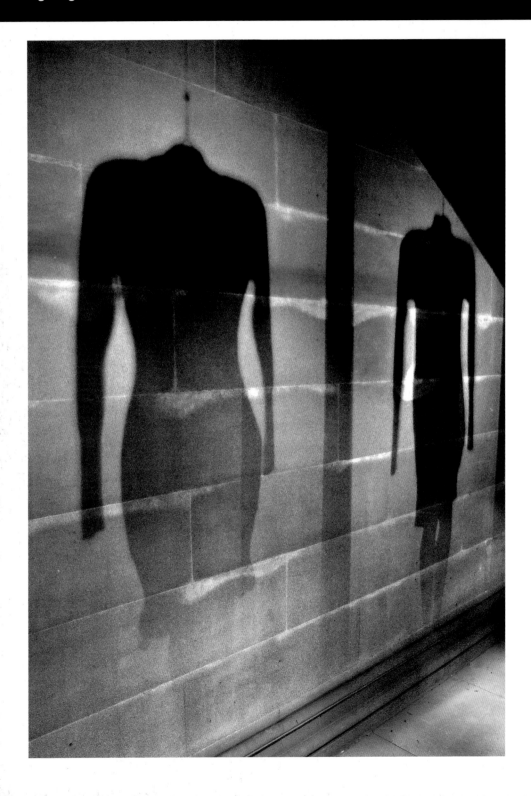

## Lighting contrast

When there is no light at all a subject has no contrast. In 'flat' or even light, the subject contrast is the only contrast. But if two light sources of different powers are used on a subject with no subject contrast (an all-over neutral toned object for example) then the light itself has contrast. There is a lighting contrast, which is the difference between the brightly lit parts and the dimly lit parts of the subject. Traditional photographers would often advise you to expose colour materials in flat light – to 'have the sun on your back'. This technique came about as a way of limiting the lighting contrast so as not to challenge the limited exposure latitude of early colour films, especially colour transparency materials.

By differentially changing the amount of light falling on a subject we can control the overall contrast. Evenly lit, the subject contrast range will equal the reflectance of the lightest and darkest tones. Changing the lighting contrast by using different light sources of different strengths can increase this and the ratio of these lights is called the lighting ratio.

The studio portrait is the usual subject through which photographers learn about lighting ratio. Two lights of different powers – or a single light and its reflected energy – can be used to create highlights and shadows on the human face. This is usually done about the centre line of the face, as in split lighting. This can even be achieved outdoors by positioning a subject relative to the sun or bright sky and controlling the reflection in the shadowed side of the face by placing the subject near a wall or using a photographic reflector. The main light illuminates one side of the face and casts shadows. It is then the job of the fill light or reflector to keep the modelling produced by the main light but to moderate the contrast.

**Shadow fashion (facing page)**
The wall itself has no contrast – the image is made solely from the light and shadow that falls on it.

**Photographer:** David G Präkel.

**Technical summary:** Nikon D100, 18–35mm f/3.5–4.5D AF ED Zoom-Nikkor at 18mm, 1/13 sec at f/3.5, ISO 200.

## Subject brightness range

Subject brightness range is the combination of subject contrast and lighting contrast. If a subject with a contrast of 8:1 is lit by lights in a ratio of 4:1 then the overall subject brightness range will end up as 32:1 (8 x 4:1 x 1).

subject brightness range = subject contrast x lighting contrast

Both film and digital sensors are limited in the subject brightness range they can handle. Least capable is colour reversal material, which can only deal with a range of about five stops – that represents a subject brightness range of 32:1. Black-and-white and colour negative films have seven-stop latitude and can deal with a brightness range of around 128:1. The average outdoor scene has a range of seven stops (128:1) and it will come as no surprise that glossy black-and-white photographic printing paper (wet chemical, not inkjet) has the ability to show exactly this range of densities. Matt paper cannot show the same density of black and has a much more restricted dynamic range.

Because black-and-white film allows the photographer to control the amount of exposure, choice of developer and length of development time, it is possible to deal with a subject brightness range of up to 11 stops – a ratio of over 2000:1. These techniques of exposure adjustment and compensation in development are covered in the sections on the Zone System and Tone compression and expansion on pages 96–101.

An eight-bit digital image theoretically has an eight-stop range (256:1) though this is never achieved in practice – it is best to assume a seven-stop range at best. The sensor in a digital camera can, however, record not 256 levels of light but over 4,000 – taking the raw, unprocessed data from the sensor produces a 12-bit file with a theoretical range of 12 stops (4096:1). Again it is best to assume a more limited range of about 11 stops. Digital raw files have greater latitude than JPEGs and can match or better black-and-white negatives. High dynamic range (HDR) imagery pushes the ability of the digital medium to handle wide dynamic range images even further. The downside of HDR imagery is the need for a series of under- and overexposed images that are then combined into a single 32-bit high-dynamic range image – not an ideal technique for anything other than studio still life, architectural or landscape photography (on windless days!).

**Harley (facing page)**

Wide subject brightness range is the combination of strong light and shadow (lighting contrast) and the bright chrome and black paint of the bike engine (subject contrast).

Photographer: David G Präkel.

Technical summary: Nikon D200, 18–200mm f/3.5–5.6G VR AF-S DX IF-ED Zoom-Nikkor at 65mm, 1/320 at f/9.0, ISO 100.

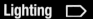

## Metering

Though modern camera light meters will take into account elements such as brightness distribution in the image, focal length of the lens and point of focus, it is still important to realise that the reflected **light meter** in a camera will expose for grey. Images that are predominantly white or dark toned will be under- and overexposed by the camera in its attempt to produce an acceptable average exposure in every case. Intelligent use of exposure compensation is essential. Film users may have to bracket exposures while digital camera users have the advantage of the camera histogram. Many advanced workers will choose to use a light meter that measures the light falling on objects (an incident hand-held light meter), rather than rely on an integral meter in the camera body that measures reflected light from objects.

A technique that helps with film (and can of course be used with digital cameras) is 'metering for the shadows'. Meter only areas of important shadow detail and compensate by two stops. For example, if the camera meter reads f/5.6 for the shadows, expose at f/11. Measuring the brightest and darkest points in the image with a spot meter function and setting the exposure halfway between the two is an alternative.

Some workers will use substitute metering; rather than take a reflected light meter reading from the subject, they use a known reference and take a reading from that instead. It is of course ideal to use a mid-grey reference card (an 18 per cent reflectance **grey card**) for this purpose but with suitable compensation, it is possible to use either a white card or the palm of your own hand. As one photographer put it: 'you always have your hand with you'.

The camera histogram can be used to double check that a correct exposure has been obtained. The first 'rule' is that the graph should not be cut off at either the black or the white ends of the histogram – in other words, there should be no 'clipping'. This represents lost information that at the white end shows as blown-out highlights with no near-white detail and at the black end as blocked-up, inky-black shadows. Some cameras intentionally underexpose to avoid blown-out highlights. The digital camera display can usually be set to show highlight areas that have not been adequately recorded; these areas will flash on and off as a warning.

**light meter** measures intensity of light for photography, giving values as a combination of shutter speed and aperture or a single exposure value (EV) number for a given film speed or density
**grey card** standard piece of card that reflects 18 per cent of the light falling on it to provide an exact midtone light reading

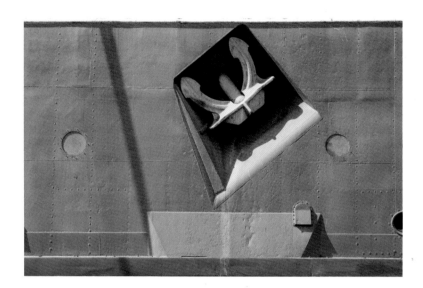

## Black ship in the sun (above)

Matt black paint in full sun is a particularly difficult subject. Metering from the overall scene will result in an image that is far too bright (top). This has to be treated like a scene where shadow detail is important – meter for the shadows and expose for up to two stops less.

**Photographer:** David G Präkel.

**Technical summary:** Nikon D100, 28-85mm f/3.5-4.5 AF Zoom-Nikkor at 66mm, exposure 1/350 at f/11 ISO 200, meter reading 1/180 at f/9.5.

Given that the histogram does not hit either the black or the white end of the scale, it should ideally be skewed to the right to give the best **noise**-free results. The digital sensor in a camera is a linear device with just over 4,000 levels to play with; it has to give over 2,048 of its 4,096 levels to the first stop where the brightest parts of the image are recorded. Each subsequent stop records half of the light of the previous one, which is always half of the remaining numbers. So the next stop gets only 1,024 levels, the next gets 512 and so on. This technique is often referred to as 'exposing to the right'. Following this advice will produce noise-free images but they will almost certainly look unnaturally bright and will need post-capture adjustment in a raw file converter to look natural.

Slight underexposure is commonly recommended as a way to avoid blown-out highlights. Though underexposure will reduce the chance of highlight clipping, it will show greater noise in shadow areas after adjustment than the 'expose to the right' technique.

When working with colour filters to change the look of black-and-white film it is sometimes best not to use automatic exposure mode or the camera's TTL (through-the-lens) metering. Filters reduce the light energy from some part of the visible spectrum to produce their effect. Because of this, an exposure increase from that suitable for white light is needed. Some TTL camera meters do not respond well to filtered light and can misread. If you do not have an alternative to the camera meter, bracket the shot with half and one stop under- and overexposures around the indicated exposure value to be on the safe side.

Alternatively, you can take a meter reading before the filter is fitted to the camera and adjust that reading according to the filter factor recommended by the filter manufacturer. A filter factor of x2 means you add one stop (double the shutter speed or open the lens up one stop); a factor of x4 means add two stops, and so on. (A full list of the effects of filters and filter factor adjustments is given on page 30 of my book *Basics Photography: Lighting*, published in this series.) Of course, compensation for filters must be made to any reading taken with a hand-held incident light meter – some photographers reduce the **ISO** setting accordingly on the meter so they do not forget to make an allowance for the filter. Meters with two ISO settings are particularly useful in this regard. A filter factor of x2 would mean halving the ISO, for example from 100 to 50. Details of metering when using graduated filters are given on page 24.

**noise** out-of-place pixels that break up smooth tones in a digital image. Can be colour (chroma) noise or luminance (luma) noise or a combination of both
**ISO** International Organization for Standardization – the body that sets standards for film speeds and matching digital sensitivity. Measure of film speed or digital sensitivity

**Newabbey, Scotland (right)**

Though modern camera meters make an excellent job of complex and high contrast scenes, they can skew the exposure subjectively too dark or too light. In one the shadows will block up and in the other highlights will blow out. The exact exposure will depend on the relative size and position in which the bright and dark areas fall in the image and where the scene is focused. When it is important to retain best shadow and highlight detail it can help to meter into the shadows, then meter the highlight and expose in between – some spot meters offer an averaging function.

**Photographer:** David G Präkel.

**Technical summary:** Nikon D100, 70-300mm f/4-5.6D AF ED Zoom-Nikkor at 70mm, 1/500 at f/11 ISO 200.

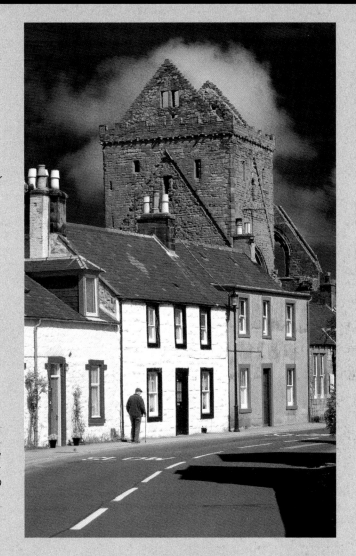

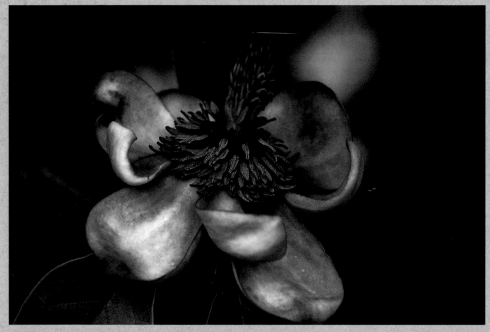

# High-key and low-key imagery

The word 'key' in the context of low- or high-key means the tonal appearance of the finished black-and-white print. The skewing of the tonal range towards dark or light can be exaggerated by the photographer. Of course this has a major impact on the mood and emotion conveyed to the viewer. A high-key image will be read as ethereal and innocent; a low-key image as gloomy and weighty, if not positively foreboding. Traditionally, gender stereotyping leads to females being recorded in high-key settings and men in low-key settings, but the contemporary photographer can of course play with, even contradict, this expectation.

Certain misunderstandings can arise when talking about high-key and low-key black-and-white images. They should not be confused with dark, underexposed or light, overexposed images. Both high- and low-key images are fully toned with a range of greys, from solid black through to paper white. However, a high-key image will have predominantly light tones while a low-key image will show predominantly dark tones. Using a reflected light meter to set the exposure for either high- or low-key images will result in **underexposure** or **overexposure** respectively, as the meter will suggest an exposure that will produce an average mid-grey tone. It is important therefore to use an incident light meter if one is available in order to measure the light falling on the subject rather than the reflected light.

Though you might think of them as low-contrast images, correctly exposed high- or low-key images will have a strong contrast. In fact, it is important to guarantee or introduce a dark shadow, however small, to establish that this is a true full-toned image and not a poor exposure. That tiny point of dark in the high-key image or of bright light in the low-key image is the necessary ingredient to establish the full impact of the final image.

**Rhododendron (facing page top) and Magnolia (facing page bottom)**
Strong backlighting, shallow depth of field – and having the camera lens almost inside the flower – creates an involving wrap around high-key image with predominantly light tones (top). Low-key presentation with a bias towards darker tone creates a strong mood for this fading magnolia bloom found in deep shade (bottom).

**Photographer:** David G Präkel.

**Technical summary:** Nikon D100, 60mm f/2.8D AF Micro, 1/180 at f/6.7 (top), Nikon D100, 70–300mm f4–5.6D AF ED Zoom-Nikkor at 190mm 1/500 at f/5.6 (bottom), both ISO 200.

**underexposure** images created with too little light, having no highlights or light tones
**overexposure** images created with too much light, having no shadows or dark tones

## Infrared

Some of the greatest fine-art infrared images have been made using Kodak HIE true infrared film. Sadly, all versions of this unique film have recently been withdrawn. Kodak High Speed infrared is a particularly grainy film with no anti-reflection coating (anti-halation backing) and so light that travels through the film bounces back and scatters in the **emulsion**, giving a singular 'glow' to images. It is a slow-working film. The long exposures this demands means images often contain movement blur, adding to its unique look.

Other IR films are available from smaller specialist manufacturers and require that same care in loading in complete darkness. When working with IR film it is important to remember that some cameras, while light-tight against the visible spectrum, may not be light-tight to infrared. Camera bodies made of plastics can sometimes fog IR film and those with tell-tale windows over the film canister to show what film is loaded can also produce fogging. Loading needs to be done in very subdued lighting or even in the darkroom.

Just as the colours of the spectrum can be split by a prism from white light because of their different wavelengths, long wavelength infrared light does not focus at the same point as other visible light. Older prime lenses may have a red dot on the lens barrel that shows the offset required to accurately focus infrared images. You first need to focus the scene without the filter fitted, refocus the lens as marked by the IR dot and then fit the filter. Details for modern zoom lenses can be found on websites specialising in infrared photography.

Film manufacturers do not give a **film speed** for IR film. Instead, a starting point is suggested as much depends on the filters used, the strength of the illuminating light and the infrared-reflecting properties of the chosen subject. Bracketing should produce a printable negative.

So-called near-red films have extended red sensitivity but also react to visible light – Ilford SFX is one such film and is now being produced again in small batches after being withdrawn from the market. These films can be exposed through red, deep red or full-cut filters to achieve a range of looks, from darkened skies to a dramatic night-from-day look.

Early digital cameras showed extreme sensitivity to light outside the visible spectrum in both ultraviolet and infrared regions – many requiring so-called 'hot-mirror' filters to limit the light reaching the sensor to just the visible spectrum. Some older models are especially sought after by digital IR enthusiasts because of their extended sensitivity, which gives a truer IR look.

**emulsion** coating on film or paper usually comprised of gelatin with light-sensitive silver salts (halides)
**film speed** how 'quickly' film reacts to light – a measure of light sensitivity

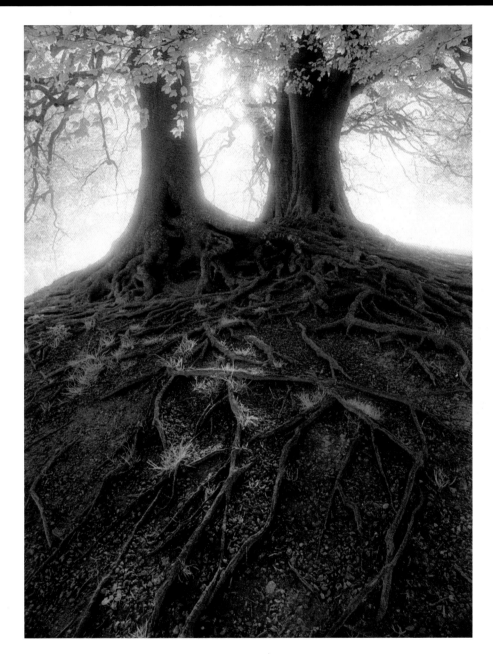

**Harmony (above)**

Infrared black-and-white images can often carry a feeling of alienation or otherworldliness; here, however, the classically bright foliage and glow of the medium produces a true feeling of tranquillity.

**Photographer:** Kathy Harcom.

**Technical summary:** None supplied.

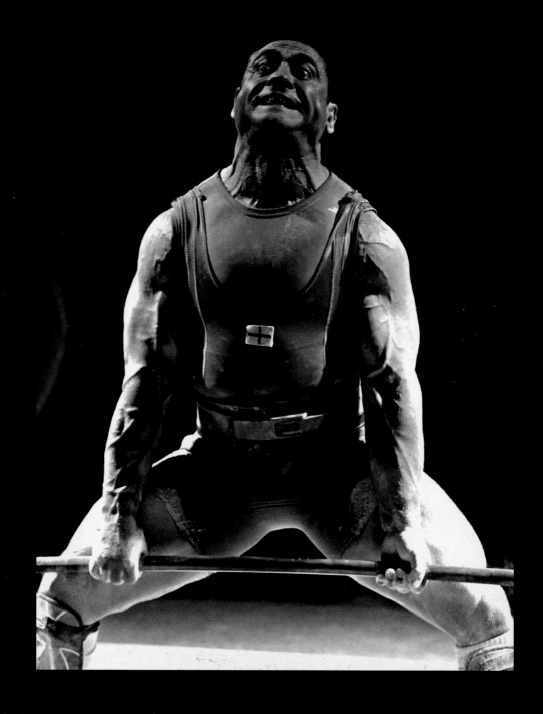

This chapter looks at different ways of capturing and choosing the look of black-and-white images. A finished black-and-white print can be produced from a variety of image sources. Each will have its own distinctive qualities. The use of black-and-white film negatives is the most obvious route to a black-and-white print and a number of variables can determine the appearance of the final image. Film developers, almost as much as the initial choice of film, will determine factors such as contrast, tonality and grain.

'Colour' films that produce black-and-white negatives during processing in conventional colour chemistry are perhaps a less well-known route to a fine black-and-white print. These are the so-called 'chromogenic' films. Not only are they convenient to process but they also produce smooth-toned negatives based on dyes and not silver grain. These films both scan and print well. Instant films (peel-apart films from Polaroid) still have a following among black-and-white photographers as one material can produce either a finished negative or print.

In the digital domain black-and-white negatives, colour film negatives or transparency material can be scanned and converted to produce a black-and-white image. Finally, a digital black-and-white image can be captured in-camera or created later from a digital colour original using computer software.

**'I also developed films slightly too warm, which was kind of by accident as I was too impatient. That gave the pictures more contrast and grain.'**
*Anton Corbijn, Dutch photographer and filmmaker*

**Powerlifting – Fit to burst (facing page)**

A striking black-and-white conversion from an original digital colour image.

**Photographer:** Peter Simmonds.

**Technical summary:** None supplied.

## Film and developer

As digital technology, with its convenience and speed, has taken over the world of imaging, the choice of films has steadily reduced. Companies have either gone out of business or have stopped producing specialist materials that were used only by a small section of the market. In recent years many films have been discontinued. For instance, Agfa films are no longer produced. Films such as Agfa APX25 – once the first choice of black-and-white landscape photographers – and the unique black-and-white reversal film, Agfa Scala, are just a memory for those lucky enough to have used them. Kodak has discontinued manufacture of its famous Technical Pan that was unsurpassed for sharpness; even Kodak HIE High Speed Infrared has been withdrawn in all its formats.

But although choice is now more limited and the available film 'looks' less extensive, there are still films made in the old-fashioned way that can provide something unique for the black-and-white photographer. Most come from smaller companies – often in Eastern or Central Europe – that use old production methods and sell through specialist retailers. Their films may take some tracking down but the results can be well worth the effort involved.

Choice of developer will have a big influence on how the negative image will form. Film development gives the greatest control of contrast, for example. You can change film performance by your choice of developer or processing times. You can even correct for exposure errors to some extent. It is important to choose an appropriate developer and follow the enclosed instructions closely, especially with regard to agitation, temperature and development time. Today's popular developers in both powder and liquid form would generally be classed as fine grain developers, though however 'fine grained' the developer it will not make high-speed films appear any less grainy.

Developers with very low-contrast performance can be used to create pictorial images from high-contrast/high-resolution graphic arts films. High-contrast developers can also be purchased. Some developers offer increased **acutance** or edge sharpness. There is a vast body of knowledge in the public domain about the effect of different developers on different films – the formulae for discontinued commercial products are even available, enabling very dedicated photographers to 'brew up' their own developers from basic chemical ingredients.

### Ready for the 'off' (facing page)

An eager young competitor waits impatiently for the race to get underway – puppy trailing at a Northumberland country show. Film and developer combination was chosen to suit the subject with its particularly crisp grain structure and high-contrast working.

**Photographer:** David G Präkel.

**Technical summary:** Leica M6, 90mm f/2.8 Tele-Elmarit, exposure not recorded, Kodak Tri-X in Rodinal.

**acutance** measure of the sharpness of a print or negative

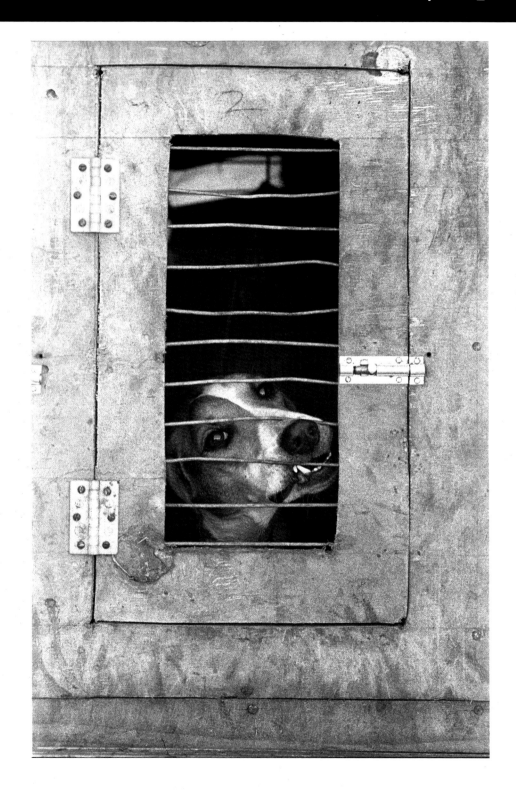

## The 'look' of film

As we have already explored, film is not equally sensitive to all wavelengths of light. Every film has a different spectral sensitivity and this is part of what creates the distinctive look of one film versus another. Manufacturers have tried over the years to produce general-purpose films for the consumer market without a distinctive 'look' but the real interest now lies in films other than these.

**Film grain** is perhaps the most noticeable difference between different emulsions. Older films tend to have a strong granularity. Some photographers love this look and work with it; others want the smoothest tonalities from films so fine grained they are almost grain free.

Part of the film story goes back to the sharply rising price of silver on the markets in 1973–4. Major film manufacturers saw their livelihood at risk. They tried to reduce their dependence on large quantities of silver. The new films that came from research during that period used differently shaped silver halide crystals that had a flatter shape with a greater surface area. These cut out more light for the same amount of silver as conventional grain. They achieve this by growing around the edge of the crystal during development. Kodak named their films T-grain emulsions after these so-called tabular (broad and flat like a table-top) grains; Fuji developed Sigma Crystal Technology and Ilford Core-shell crystal technology to achieve this more effective utilisation of silver.

These films with their flattened grain have a different look, when printed up, from an old-fashioned, silver-rich film such as Kodak Tri-X Pan, noted for its distinct graininess. You can find both traditional, silver-rich films and more modern, flat-grain films in the inventory of most film manufacturers – often the two films even have the same film speed. Ilford offers Pan-F and FP4 alongside the modern film formulations in its Delta range. Kodak still offers classic emulsions such as Plus-X Pan alongside its TMax range of tabular grain films.

Three effects are at work here: the spectral sensitivity, the characteristic (contrast) curve and the grain, to create the distinctive look of a print made from any film negative. Careful initial choice of film, filtration, processing and lighting can even recreate the look of an older style of photography. Changing film speed in the camera and compensating for this in development has a major impact on the grain structure and contrast of the processed negative.

The illustrations shown opposite demonstrate some of the differences between two Ilford films. The Pan F characteristic curve shows steeper slope than HP5 Plus, meaning this slower film has inherently greater contrast. Pan F is an ISO 50 film and HP5 Plus an ISO 400 film. The spectral sensitivity shows subtle differences in the reaction of the two films to different wavelengths of light. The grain comparison is from actual negatives, normally developed in the manufacturer's recommended developers – a $0.5mm^2$ portion of a mid-grey tone has been magnified to show the real grain structure of the two emulsions.

**film grain** appearance of the individual specks of silver salt that make up the tones in the final image

**Two Ilford films compared**

**Ilford PanF**

Density (D)

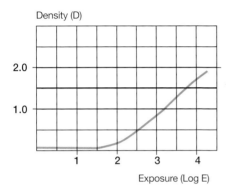

Exposure (Log E)

Sensitivity

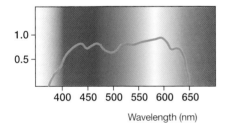

Wavelength (nm)

Microphotograph
of grain in midtone
(approx. 0.5mm²)

**Ilford HP5 Plus**

Density (D)

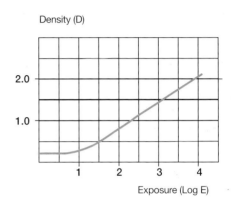

Exposure (Log E)

Sensitivity

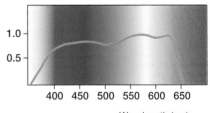

Wavelength (nm)

Microphotograph
of grain in midtone
(approx. 0.5mm²)

## Staining developers

**Pyro** developers cause a good deal of controversy in the photographic community. Adherents hold an unshakeable belief in pyro's almost magical properties, while others argue that modern film/developer combinations offer the same advantages without the difficulties of working with unpleasant, sometimes unpredictable chemicals.

'Pyro' is a catchall title for two very old developing agents: pyrogallol and pyrocatechin, first used in the 1850s. Developers convert the silver halides that were exposed to light in the camera to metallic silver. The by-products of this chemical process vary depending on the developing agent used. With pyro these oxidation products stain or 'tan' the gelatin. The gelatin is stained in proportion to the density of the image (in proportion to the quantity of silver that is reduced). Tanning is therefore stronger in the most strongly blackened parts of the negative image. Where the gelatin is tanned by these developers it is also hardened in a process not unlike tanning leather (remember that gelatin is an animal by-product). In these areas, access to the developing agent is made more difficult. This slows down development in those parts of the negative that received the highest level of exposure — the highlights. As highlight development is held back, a degree of contrast compensation or equalisation occurs. This gives pyro-developed negatives good highlight definition and makes the negatives easier to print.

A side effect of the gelatin tanning is an increase in acutance or apparent edge sharpness. This is another advantage claimed for pyro. The downside of pyro developers is that they are as effective at staining you as they are film. In addition to this, both pyro agents are highly poisonous and should be used with extreme caution. For those who do not want to deal with the raw ingredients, successful developing 'kits' are available, such as PMK, Pyrocat-HD and Diaxactol. The chemical solutions have a short and unpredictable shelf life and should be freshly made up.

Pyro negatives show a distinctive staining, sometimes yellow and sometimes green – this can have a particularly strong effect on variable-contrast photographic paper, which is blue–green sensitive. The staining also masks film grain, making prints from pyro negatives very smooth, while the stain colour in general reduces print contrast and allows darker tones to print out. In practice, much depends on the precise colour of the final staining with yellow–brown negatives producing different effects under the enlarger from green-stained negatives.

**pyro** short form of pyrogallol (1, 2, 3-trihydroxybenzene) – photographic developing agent that causes staining in areas of heavy development, producing negatives with fine tonality and clear highlight detail that are easy to print and scan (used also of pyrocatechin)

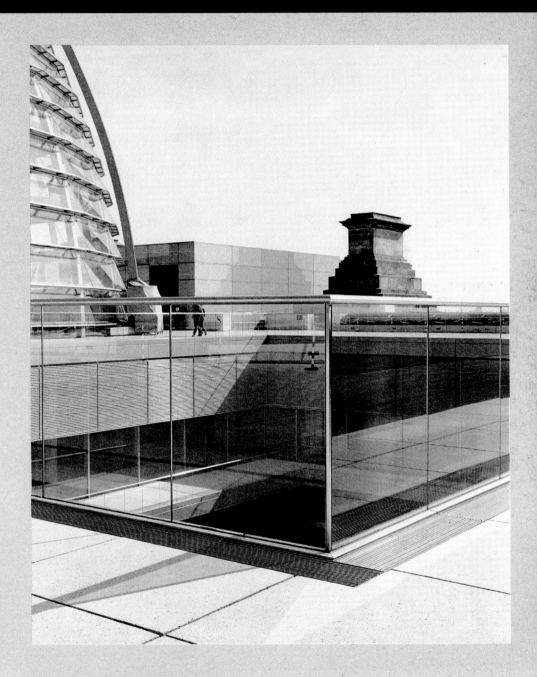

**Reichstag building, Berlin (above)**

Pyro development gives great tonal control in the finished print even from such a high-contrast subject. Film grain remains as an attractive character and is not obtrusive.

**Photographer:** Steve Macleod.

**Technical summary:** Kodak Tri-X Pan developed in pyro and printed on Forte Polywarmtone paper.

## Exposure Index

One of the things you have to remember to do with a film camera is set the camera's light meter to the speed of the loaded film. Only that way will you get a good exposure, with both highlight and shadow detail. However, you would be annoyed if you set your light meter to the film speed rating on the box only to find the manufacturer's figure was wrong. Looking carefully at a range of films you will find that while some film speeds are rated in the familiar ISO units, others use either an EI number or a P number, such as in TMax P3200.

Very simply expressed, the 'speed' of a film is how quickly it reacts to light to turn black. This is a standard measure of its sensitivity to light. National standard-setting bodies gave ASA and DIN numbers, which were then rationalised by the International Organization for Standardization into the familiar ISO numbers. ASA numbers were arithmetic and largely used in America and Japan; DIN numbers were largely used in Europe and based on a German logarithmic scale. Both numbers live on in the full ISO number, such as ISO 100/21° (arithmetic/logarithmic) but we tend now to use only the arithmetic value where double the number means double the speed – one stop faster.

EI stands for Exposure Index. EI numbers come in when a film has been designed to be exposed in conditions that are different from those specified in the applicable ISO standard. ISO speed ratings use highly standardised testing methods that may not always relate closely to real world conditions. EI numbers are also used when the manufacturer cannot guarantee speed results with the ISO standard developers. Instead, they recommend the film is processed in their own developer. Look carefully at Kodak's TMax range of films and you will find an ISO 100 film and an ISO 400 film but the 3200 speed film is graded P3200. The P stands for 'push' as in 'push process'. The nominal speed for TMax 3200 is EI 1000 when the film is processed in TMax developer but EI 800 when it is processed in other black-and-white developers. The speed you use depends on your needs and the manufacturer recommends tests to determine the appropriate speed.

All this matters because your film/developer combination may give a different result from that predicted by the ISO number – for best exposure you would be better off changing the light meter setting to a different ISO number. You could, for instance, expose an ISO 400 film at EI 800 if you needed the extra speed-to-stop motion or you were working in low light. You would then have to compensate for the reduced exposure by increasing the development time. This is known as 'push' processing: you have pushed the speed up. You can also 'pull' the speed down by exposing a high-speed film at a slower speed and giving shorter development times. Tri-X Pan, an ISO 400 film, can be successfully rated at EI 200 and developed in Kodak Xtol developer to reduce the graininess.

Underexposure + increased development = increased grain and contrast

Overexposure + reduced development = reduced grain and contrast

It is always best to use whole stop changes (from 400 to 800, or from 200 to 100, for example) and to follow manufacturer's instructions for push and pull development times carefully, as these will take into account unwanted changes in contrast. You must learn to override the camera's automatic DX (film speed) sensing if you want to push or pull film.

| Overexposure (+2 stops) | Normal exposure | Underexposure (-2 stops) |
| --- | --- | --- |
| Overdevelopment (N+1) | Overdevelopment (N+1) | Overdevelopment (N+1) |
| Overexposure (+2 stops) | Normal exposure | Underexposure (-2 stops) |
| Normal development | Normal development | Normal development |
| Overexposure (+2 stops) | Normal exposure | Underexposure (-2 stops) |
| Underdevelopment (N-1) | Underdevelopment (N-1) | Underdevelopment (N-1) |

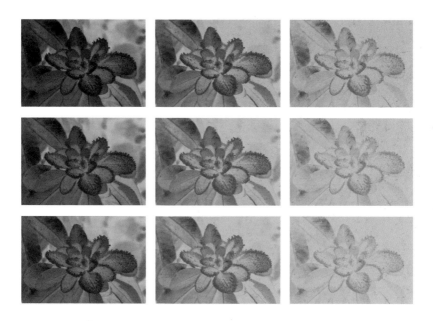

**Melting frost (above)**

Matrix of negatives showing exposure and development.

**Photographer:** David G Präkel.

**Technical summary:** Leica R8, Leica 100mm APO-Macro-Elmarit-R f/2.8, 1/30, 1/125 and 1/500 at f/11, Ilford FP4 developed in Ilford LC-29 dilute 1:29, N+1, N and N-1.

### Crossing (above)

Chromogenic film is free from silver grain and gives wonderful smooth images with velvety tones.

**Photographer:** Steve Macleod.

**Technical summary:** Ilford XP2 Super (C-41 processed), printed on Ilford Matt FB and cold thiocarbamide toned.

# Chromogenic film

Derived from the Greek words for colour and production, in the photographic context 'chromogenic' simply means 'made from colour'. Applied to film, it refers to a type of film that produces black-and-white negatives but which is processed in colour film chemistry (C-41 process or equivalent). Chromogenic films have the advantage of being effectively grain-free as there is no retained silver in their negatives. The density of the image is made up from tiny clouds of dye, centred on where the original silver grains that reacted to light in the film were removed during processing. The negatives have a 'softer' look – they do not lack resolution or contrast; but they are distinctly 'ungrainy'.

Chromogenic film has unique and attractive qualities for the black-and-white art photographer. It is also a convenient way for film photographers who do not have a darkroom of their own to shoot black-and-white film and have the convenience of high-street processing. The negatives scan well. One of the major attractions of chromogenic film is its exposure latitude and ability to capture good shadow and highlight detail. Tonal transitions are particularly fine and smooth.

One of the largest markets for chromogenic film has been for wedding photography. It is interesting to present colour and black-and-white wedding pictures to viewers and listen to their comments. Colour images usually generate remarks about the clothes and fashions; black-and-white images seem to bypass this topic and people comment more on the characters in the images and their relationships. Colour wedding photographs seem to date very rapidly while black-and-white images have a timelessness. Many wedding photographers nowadays offer both colour and black-and-white prints of a couple's wedding images.

In the past, however, it was inconvenient for photographers to expose both colour and black-and-white film and have to have them processed and printed separately. Kodak originally produced chromogenic film especially for wedding and portrait photographers. The black-and-white films could be processed in the same chemicals as the colour negatives and even proofed and printed on the same channel in a mini-lab. Early processing gave chromogenic negative prints a bad reputation as many labs could not initially produce neutral prints; they would often turn out with a green, magenta, lilac or brown cast. The colour casts also varied from shot to shot. Luckily that seems to be in the past. Chromogenic film can now produce neutral black-and-white images on colour paper with convenience.

## Film grain

Grain is unique to film. Unlike pixels, its size, shape and distribution are randomly variable. Every film has an inherent grain size, which corresponds closely with its sensitivity to light; its 'speed' in other words. Big crystals are more sensitive to light but create bigger grain in the developed film, hence fast films are unavoidably grainy. Developers play an important role in determining the final size of the grain in the negative. The same type of film developed in two different developers can produce two sets of negatives which will have quite a different look, not only having different contrasts but also with a different appearance to the grain.

Manufacturers have always tried to increase film speed while reducing the appearance of grain. Yet film grain can enhance the image rather than detract from it; some of the best black-and-white photographs use strong grain as a compositional element. It has again become the fashion to expose and develop images for increased grain – you will even hear the look enshrined in the description of black-and-white social documentary photographs showing 'gritty reality'. Today most popular developers can be classed as fine grain. However 'fine grained' the developer it will not overcome the underlying graininess of high-speed films.

The grain of already processed film can be made stronger by the use of a chemical **intensifier**. Today's intensifiers offer little more than one stop of extra density and are based on selenium and chromium chemistry. These chemicals work on the metallic silver in the film and build up each particle. Intensification is proportional to the amount of silver in the image so the darker parts of the negative are affected more, which increases the contrast in the image. There is little or no effect on shadow areas.

Older intensifiers, based on mercuric chloride or uranium nitrate, are nowadays considered too poisonous to be used, although their effects were far stronger. Uranium-intensified negatives were coloured a deep red, which added spectral density to their physical density. Intensifiers can be used in an attempt to recover or make printable negatives that were underexposed in the camera or that were underdeveloped. It is, however, probably better to consider their use for artistic purposes. For increasing the appearance of grain, for example, not as a remedy for poor camera work.

**intensifier** chemicals used to improve the density of black-and-white film negatives. Usually coarsens grain structure but may make underexposed or underdeveloped negatives useable

**Film grain**
Clear grain structure can be seen in this enlargement of the central portion of the image shown on page 83.

**Chemically intensified half-frame negatives from the 1960s**

Please consider the effect on the environment before using chemical intensification – read all health and safety advice.

# Digital noise

Digital 'grain' is noise. This can be thought of as 'pixels out of place'. In an area of smooth tonal change, the RGB numbers should change slowly and be close together as one tone becomes another. An abrupt change in one value or one set of values will be seen as noise. While film grain can be an enhancement, it cannot really be said that digital noise has any truly attractive properties. Film grain is random in both size and distribution, unlike the regular pattern of the pixel mosaic. Some of the 'film look' software plug-ins looked at later in this book try to reintroduce the appearance of film grain but large digital files are needed before pixels can be used successfully to imitate the look of fine-grain film.

Digital noise can come from two sources: high ISO sensitivity settings on the camera and long exposures. Some cameras feature long-exposure, noise-reduction programmes and automatically take a second picture with the shutter closed in a mathematical attempt to subtract the noise from the first image. Digital black and white captured on camera is subject to noise from any of the colour channels, although the contribution from the blue channel may be higher. Noise filtering this channel before it is combined with the others may make the appearance of noise less intrusive. (Film scanners are also known to produce more noise in the blue channel when scanning colour negatives.) Very few workers intentionally use digital noise as film photographers would use grain, and there are many pieces of software designed to smooth out the tones and get rid of as much digital noise as possible.

The effect of colour (chroma) noise can be removed if a digital RGB to black and white conversion is done via a colour model that separates the luminance (luma) and chroma signals. The amount of noise in each channel will depend on the originating camera; some manufacturers are now careful to apply separate and appropriate noise reduction algorithms to the luma and chroma data.

Scanning film can produce the worst of both worlds as the grain of the film can build up an unpleasant interference look at certain scanning resolutions. This is behind the observation that some films will scan better than others; it depends on the size and frequency of the grain and the common scanning resolutions.

**Candlelit supper (facing page)**

Shot under low-level domestic lighting with digital sensitivity set to equivalent of ISO 6400. This has produced heavy digital noise, which adds atmosphere and aging to a modern digital image.

**Photographer:** David G Präkel.

**Technical summary:** Nikon D100, 60mm f/2.8D AF Micro, 1/80 at f/4.8 ISO HI-2, greyscale conversion in Lightroom (Antique Light preset).

# The Zone System

The Zone System was originally developed for the slow and considered pace of the large-format photographer using single sheets of film. However, it still has important applications for black-and-white photographers using any type of film or digital camera. The system was introduced by landscape photographer Ansel Adams and his co-worker Fred Archer in 1941 (it was originally based on articles published in the 1940 Fall and Winter editions of *US Camera Magazine* by John L Davenport). Adams used it in his teaching at the Art Center School in Los Angeles to help bridge the gap between the science of sensitometry (the study and measurement of light-sensitive materials) and creative, expressive photography.

The Zone System was developed and refined by Adams in an effort to avoid highly technical and specialised sensitometric testing of film and paper. Instead, he proposed practical tests that could be carried out by a competent and thorough photographer. The scale of zones has changed over the years. This book adopts the eleven-point scale running from Zone 0 to Zone X, which better reflects the performance of modern films. Adams' original scale did not include Zone X. Roman numerals are still used for the zones today.

The difference between each zone is one stop, representing a doubling or halving of the light (luminance change). On this scale, Zone 0 represents solid black and Zone X pure white in the image. Zone V is the mid-grey point of the scale with all practical image information falling in and between Zones I and IX. Adams refers to this as the 'dynamic range', with Zones II to VIII as the textural range – the range that can show definite texture. The revised eleven-point scale more accurately matches the latitude of modern black-and-white film emulsions, with the dynamic range having a range of eight stops and the textural range having a range of six stops.

Two key concepts in the Zone System are the idea of 'place' and 'fall'. All light meters are calibrated for 18 per cent reflectance grey. They will always give an exposure reading that results in a mid-grey value in the finished print (with correct development and printing). An 18 per cent reflectance grey card is mid-grey; precisely where we find Zone V. Therefore, if you measure a grey card with a light meter and take an EV (exposure value) reading (one that doesn't yet divide the exposure up into potential shutter speed and aperture combinations) you have effectively placed that reading on Zone V. If you then measure a dark area and get an EV reading three stops lower, that luminance has to fall on Zone II. You can place any luminance value on any zone – and so determine the camera exposure – and see where other key tones will fall. Adams advocated light meters with home-made zone scales but you just need to use a meter that can accurately measure a small enough area containing a single tone; some camera spot meters can achieve this, though a dedicated spot meter makes life considerably easier.

Zone 0    Total black in print – no useful density in negative.

Zone I    Threshold. First step above complete black – slight tonality, no texture.

Zone II    First sign of texture. Deep shadow detail (slight).

Zone III   Average dark materials.

Zone IV   Average dark foliage and stone or landscape shadows. Shadow value for white skin in sunlight.

Zone V    Middle grey (18 per cent reflectance) grey card. Dark skin, grey stone and weathered wood.

Zone VI   Average white skin in sunlight. Light stone. Shadows on snow in sunlight.

Zone VII  Very pale skin, light grey objects.

Zone VIII Whites with texture, highlights on white skin.

Zone IX   White without texture, close to pure white. Snow in flat sunlight.

Zone X    White of printing paper.

To review the Zone System and show how any photographer can use it:

- The system is a progressive, evenly spaced, series of print tones.

- The interval between each zone is the equivalent of one stop.

- A reflected light meter reading from a subject tone will give a correct exposure for Zone V (Zone V is mid-grey).

- Changing exposure by a stop up or down will move that subject tone up or down the Zone scale (place) and all related tones with it (fall).

For example, if you meter a well-lit, white porcelain cup, your meter reading will place the white cup on Zone V. In the envisaged finished print the cup clearly belongs on Zone VII, which is three zones away from where it will be if you use the indicated exposure. You need more exposure to make the cup brighter and to move it from Zone V to Zone VII. You will need to give two stops more exposure by giving a longer exposure, opening up the lens aperture or some combination. The revised exposure now places the white cup into Zone VII. The important thing then is to see where the originally metered highlights have moved (fall) in the finished print. If they were more than three stops brighter than the cup then highlight detail will now be lost in Zone X – the paper.

We can only touch the surface of the Zone System in these pages and explain the philosophy behind it, the problems it seeks to overcome and how it was intended to give interpretative freedom. The full details of practical tests to establish a precise method of working for your camera, tastes and materials are best found in Adams' own series of books, especially his books entitled *The Negative* and *The Print*. Whatever some critics may suggest, Adams did not wish to confine photographic imagination in a technical straitjacket.

| 0 | I | II | III | IV | V | VI | VII | VIII | IX | X |

**Roofs of the North Shields fish quays (above)**
Zones of the eleven-point system seen in a full-toned image.
**Photographer:** David G Präkel.
**Technical summary:** Leica R8, 35-70mm Vario-Elmar-R, Ilford FP4 Plus developed in Ilfosol S.

## Tone compression and expansion

Ansel Adams' 'big idea' was that if you can visualise the tones in the final black-and-white print you can make an appropriate exposure to put the tonal range in the real world where you want it in your finished print. This linking of exposure to print tones is key. Though this can be done by changing paper contrast in the printing process, Adams most definitely favoured varying film development to support his belief in the power of visualisation.

The Zone System falls neatly into two parts: the system for exposure (applicable to all photography) and the system for development (for film use only). Adams proposed a method for compressing or expanding the tonal range on to the negative by adjusting development. He could thus obtain a full-toned print from even difficult subjects or in difficult lighting conditions. This technique is obviously only available to film photographers. Digital high-dynamic range imagery (HDR) and tone mapping addresses a similar issue where the subject brightness range cannot be captured in a single exposure but uses a combination of multiple exposures to achieve a final full-toned image.

Normal film development gives a known contrast, reading from the film characteristic curve. This is the gamma (G bar) or Contrast Index (CI). Adams called this N for normal development. Therefore, when the range of tones in the subject is greater or less than normal, development can be adjusted accordingly. Development that brings down the high value by one stop is referred to as N-1 (N minus one) development, sometimes called compaction development (as it compacts down the tonal range). Expansion development N+ (N plus) is more commonly used, where increasing high luminance by one zone is referred to as N+1. As shown on pages 106–107, different types of enlarger give inherently different print contrasts; many workers use N+1 development when they know the negatives will be printed on a diffuser enlarger to overcome its lower contrast printing.

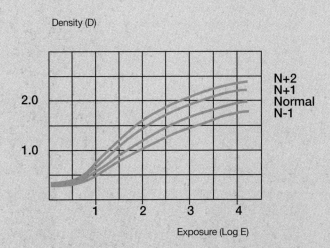

Family of development curves for Ilford Delta 3200 Professional film developed in Ilford DD-X diluted 1:4 at 20°C/68°F for 7, 9, 12 and 16 minutes, representing N-1, Normal (N), N+1 and N+2 development respectively. Note that the slope of the graph for N+2 is steeper, showing increasing contrast with increased development.

For roll film and 35mm film users, this kind of development practice only works when all the images on the film are shot in similar lighting conditions or are of similar subjects. Minor White (of the Rochester Institute of Technology) extended the Zone System to include graded papers. In his book *The New Zone System Manual*, he usefully summarised the use of adjusted development and graded paper to relate initial subject range and final print tones. For film: normal (N) development will render a normal ten-zone subject, while N+1 and N+2 development will render nine- and eight-zone subjects respectively as full scale. N-1 and N-2 will render 11- and 12-zone subjects as full scale. For paper: grade #5 gives a full-scale print from 8 ½ zones, grade #4 from 9 ½ zones, grade #3 a full-scale print, grade #2 a full-scale print from 10 ½ zones and grade #1 from 11 zones.

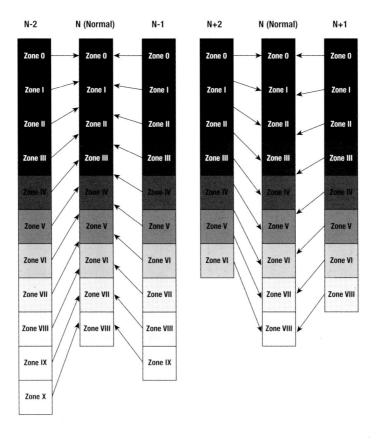

Development changes have much more effect on the high values (highlights); the low values (shadows) are controlled principally by exposure. This is the reasoning behind the commonly heard advice: 'expose for the shadows but develop for the highlights'.

**Terra cotta dogs (above)**

It is unusual to get a pair of aesthetically pleasing images from Polaroid Type 55 P/N peel-apart film, as the film negative and paper positive have effectively different working speeds.

**Photographer:** Ted Drake.

**Technical summary:** A photographic negative has been inverted to produce a positive image in Photoshop for enlargement and printing.

# Instant black-and-white film

People think of Polaroid material as either producing outdated 'happy snaps' or having a 'cool retro' look. However, it is worth remembering that master technician and fine-art landscape photographer Ansel Adams was a consultant for the company and produced some of the finest technically controlled landscape images on Polaroid film. It was Adams who persuaded Polaroid to make film for professionals.

In early 2008, Polaroid announced its intention to cease production of all instant film materials and to withdraw from this market. Some product will remain in the distribution pipeline for perhaps a year or more. Fuji produces some alternative materials – including a black-and-white Polaroid compatible pack film – that are sold in Europe and Japan but not aggressively marketed in the US. Polaroid seems keen to license production of certain instant films and has been in exploratory talks with both Harman technology Limited (Ilford) and Fuji. It seems possible, as this book goes to press, that the classic black-and-white Type 55 film, which attracts many fine-art photographers, may yet survive.

Type 55 is a peel-apart film for use in a Model 545 Polaroid film holder. This fits any 5 x 4 camera back in place of a double-sided dark slide. While other Polaroid films of this type produce a finished print and a paper negative that is disposed of, Type 55 produces either a quality negative or a proof print. As film and print have different sensitivities you can expose for one or the other but cannot get quality prints and negatives from the same exposure. Polaroid announced its complete withdrawal from the instant film market on 8 February 2008 and the closure of its film factories worldwide. The company is looking into the possibilities of licensing production of some film types to other manufacturers.

If you wish to print from or scan the large 5 x 4in negatives they have to be cleared of residual developer in a solution of sodium sulphite. Polaroid made capped plastic buckets for use in the field, to store and clear negatives; these can still be obtained. It is, however, possible to remove the exposed film in its envelope without squeezing the reagent pod between the film back rollers and to delay the development process. The film envelope can later be reinserted and pulled through the rollers in the film back to develop it under controlled conditions. You should not delay too long with the latent image awaiting development, however, as image quality will degrade.

For a good negative, an ISO sensitivity of between 25 and 40 should be presumed, while the print has a speed of ISO 80 to 160. (For details of how to expose and control development for the finest quality negatives Ansel Adams' book, *Polaroid Land Photography*, is the best source of information, though a précis of Adams' information by George DeWolfe and a new commentary on scanning Type 55 negatives can be found on the World Wide Web.)

Capturing the image as a digital file or a film negative is only half the fight. Getting a good exposure is critical for this first stage. The image, however, is still locked in the medium and needs to be realised through either conventional darkroom work or through digital image-editing software and printing.

Digital colour files can be converted to greyscale images in a variety of ways in order to achieve a range of results that map the colours quite arbitrarily to grey tones. Alternatively, a digital file can be treated to a film 'look' and reproduced to imitate the qualities of traditional wet film. The manufacturers offering film-look software are careful to imitate the contrast, colour sensitivity and grain structure of the original film they are imitating.

The most common output device for digital images is an inkjet printer of some type. This may range from a desktop printer with cyan, magenta, yellow and black inks, to a wide carriage professional printer using additional light versions of these inks, or to dedicated photo printers that use black ink only or toned black inks and fibre-based papers.

The film negative can follow one of two routes to become a finished print. Traditional darkroom work is enjoying a revival of interest, especially the alternative processes that give a unique look. Alternatively, a film original can be scanned in a dedicated film scanner or on a high-quality flatbed scanner to enter the digital output chain. This latter route has certain advantages as detailed retouching and fine-scale 'dodging and burning' (that could not possibly be achieved in a conventional darkroom) can be done without losing the qualities of a film original.

This chapter looks at how the fine print can be produced either from a digital or from a film original and considers the advantages and disadvantages of both conventional wet darkroom work and computer image editing for black and white.

**'In many ways, I find printing the most fascinating aspect of black-and-white photography.'**
*Ansel Adams (American photographer, conservationist and proponent of the Zone System)*

**Heartwood (facing page)**
This simple picture of a cut tree stump in an English churchyard was captured on a manual film camera with a heritage that reaches back to the second decade of the twentieth century. The image was realised with a film scanner originally designed for newspaper use that, when launched in 1998, offered fast, quality scans at 2,000ppi resolution. With the rapid development of digital technology, this scanner would now be considered obsolete.
**Photographer:** David G Präkel.

**Technical summary:** Leica M6, 35mm Summilux f/1.4, 1/125 at f/8, Kodak TMax 400, developed in Ilford Perceptol, scanned with Kodak RFS 2035 Rapid Film Scanner.

## Printing to match the contrast of film

Negatives are difficult to interpret, even for the experienced. The darkroom printing process is to the negative as the performance is to the music score. Not only does printing make the image come to life for a public – it must also match the characteristics of the film negative to produce a faithful rendition. This is particularly true of contrast. Judging negative contrast is best done on a light box or with the negatives held over an evenly illuminated piece of white paper or wall. They cannot be properly judged by holding them up to the darkroom safelight.

A high-contrast negative will not yield the full information it contains if it is printed on high-contrast paper. The effect will be to further increase contrast so the image will lose more grey tones and become a harsh, all black, all white image – the so-called 'soot and whitewash' look. To achieve a normal-contrast print from a high-contrast negative it must be paired with a low-contrast paper. That is of course the technically correct approach. As with all such matters, however, there is both a technically correct and an interpretative, subjective approach. Once you understand the principles, you are free to change the process to your own artistic ends. For the technically minded, quadrant diagrams or tone reproduction diagrams are available to show these relationships and how linear or otherwise the transfer is.

Film also needs to be developed with regard to the type of enlarger with which it will be printed. There are two main types of enlarger: the condenser enlarger and the diffusion enlarger.

Condenser enlargers use large lenses that concentrate the light from the enlarger lamp and direct it through the negative to the enlarger lens. Diffusion enlargers illuminate the negative with light from an opal glass or translucent plastic window. The light reaches the negative from all directions and is not coherent like the light from a condenser. The diffusion enlarger tends to minimise the effect of film grain and dust on the surface of the negative but prints about one paper grade softer. The condenser enlarger, on the other hand, produces maximum tonal separation and crisp-looking prints that are about one stop harder than from a diffusion enlarger, but any dust on your negatives will be more apparent.

Most digital image capture requires a mild contrast increase and this can be achieved through the curve control in whatever raw converter or image-editing software you use, as it gives a good visual indication of the degree of contrast applied. Controlling the printed contrast can also be achieved with curves applied to the image, preferably as an adjustment layer, or sometimes with transfer function curves in the printer drivers.

### Strawberry Fields (facing page)

Tractor automatically lays down straw around fruiting strawberry plants, Brocksbushes Farm, Northumberland.

**Photographer:** David G Präkel.

**Technical summary:** Leica R8, 19mm Elmarit-R f/2.8 with internal red filter, Kodak TMax 400, exposure not recorded. Durst M670 Diffusion enlarger, Durst A600 condenser enlarger – both images made with white light on Ilford Multigrade IV RC glossy paper. Prints made within minutes of each other and processed together – note visible dust and increased contrast on condenser enlarger print. Close inspection of actual prints shows visible grain with condenser print but not with diffuser, where scattered light minimises dust and scratches.

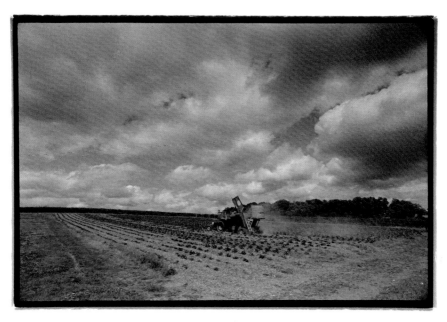

DIFFUSER ENLARGER
(DURST M670)

CONDENSER ENLARGER
(DURST A600)

## Fixed-grade and variable-contrast papers

Photographic printing paper was traditionally produced in a range of contrast grades.
These papers, still available, are known as fixed grade. A low number denotes a low-contrast
(so-called '**soft**') paper and a higher number a high-contrast ('**hard**') look. Normal contrast is
usually at two and a half on a scale of zero to five. The market has firmly swung in favour of
variable-contrast (VC) paper as this simplifies stocking; all contrast grades can be had from
one piece of variable-contrast paper. Classic papers such as Ilford Ilfobrom are still available
(as this book is being written) in four contrast grades in a gloss finish and three in a matt finish
(matt finish paper does not have as high a DMAX as glossy).

A single paper coated with a blend of photosensitive emulsions that act under different
coloured lights at different speeds to give a range of contrasts was first suggested in the
1930s. These VC papers suffered by being produced on resin-coated paper bases only, which
were not considered archival or sufficiently aesthetically attractive to the fine art market. Most
fine art or exhibition prints were made on fibre papers (no resin coating) with a fixed contrast
grade. Today VC emulsions are coated on to the full range of paper bases including heavy,
high-quality, fibre-based stock.

Modern VC printing papers are a blend of three emulsions. All three layers are sensitive to blue
and green light. Whatever light you use to expose the paper, the entire emulsion is always
exposed but, depending on the colour of the illuminating light, the emulsions react at different
speeds to give a range of contrasts. VC papers can be exposed using filters in the lamp house
of the enlarger or below the lens. These filters range from yellow to deep magenta giving
half-grade contrast steps. Alternatively, an enlarger with a so-called multi-grade head can be
used to directly dial up the needed contrast. The magenta and yellow filters in colour enlarger
heads can be used but may not give extreme contrast grades. Check exact settings in the
operating manual for your enlarger.

VC paper opens up powerful imaging possibilities to the darkroom user. One of the
advantages is the ability to control contrast in different areas of the print. To be technically
correct this should really be referred to as multiple-contrast printing. You can burn in selective
areas using a higher number filter to darken shadows. With an appropriate image, you could
even expose one half of an image using one filter and the second half with another. Extra
contrast could be introduced into an image foreground for instance, by changing the enlarger
filtration while burning in.

## Split-filter printing

A related technique to multiple-contrast printing is to use two contrast filters and two exposures on the entire image. This technique can achieve fine contrast gradation and is what should rightly be called **split-filter printing**. Split-filter printing is sometimes referred to as split-grade printing.

It is important to remember that it is the proportions of blue and green light used that make the contrast changes. This is controlled by the yellow and magenta filters of the variable-contrast filter pack. Low-contrast filters are yellow (#00), blocking blue light and letting green light through. High-contrast filters are magenta (#5) and these block green light while allowing blue through.

In split-filter printing, the proportions of blue/green light are altered using the yellow and magenta filters in a double exposure to perfectly match the print contrast to the negative. For example, a combination exposure of five seconds with the yellow filter in place and ten seconds with magenta (the #5 filter needs double the time to let through the same amount of light) would give a normal-contrast print. Higher contrast can be obtained by increasing the length of time the paper is exposed with the #5 filter; lower contrast by favouring the #00 exposure. Split-filter printing is not magic. It will not resurrect poor negatives. What it will do is produce the exact contrast needed for any negative.

Technique
**Step 1:** Test for correct highlight exposure. Use #00 filter and step test to find the time for very light density in an important highlight. Write down this time.

**Step 2:** Replace #00 filter with #5 and repeat test. The correct exposure is one that produces minimal detail in the darkest area of the print. Write down this time.

**Step 3:** Replace #5 filter with #00. Expose a full sheet of paper with the exposure time in step 1 (#00 time). Replace #00 filter with #5. Leave paper in easel. Do not knock or re-focus. Expose this same sheet of paper with the time found in step 2. Develop normally.

The two exposure times, when combined in a single print, produce the best contrast for that negative. Additional burning in of very overexposed areas can be done with the #00 filter.

**hard and soft** subjective terms used to describe high-contrast and low-contrast images respectively (also of photographic papers)
**DMAX** maximum density, not an absolute but varies from medium to medium
**split-filter printing** a method of printing using variable-contrast paper where two exposures are combined – one at a low contrast and one at high. Properly done gives ideal contrast match for any negative

10 sec

8 sec

6 sec

4 sec

2 sec
#5

| 20 sec | 16 sec | 12 sec | 8 sec | 4 sec | #00 |

**Small shy maiden (above and facing page)**
Split-filter test matrix: #00 test horizontally in four-second
increments, #5 test vertically in two-second increments.
Best exposure judged to be 12 sec #00 plus 6 sec #5.
Finished print made with this combined exposure.

**Photographer:** David G Präkel.

**Technical summary:** Leica R8, 35–70mm Vario–Elmar–R, exposure not
recorded, Ilford HP5 developed in Ilford Perceptol.

MAID OF
SPRING

£ 42.28

SHELL
GIRL
£ 27.46

## Scanning film

Scanning film should really be a one-shot process. The ideal is to get an archival quality scan from the film negative first time. This not only protects the film from unnecessary handling but provides a master digital file that can later be used to create smaller images if needed. The scan needs to be not only the biggest, but also the best possible quality to reduce the need for digital editing later in the workflow. If editing can be done in the scanner, this is the best place to do it. Squaring up the original negative in the scanner is far better in terms of final printed quality than trying to rotate an off-square scan.

The best film scanners are professional drum scanners where the film is wrapped around a rotating clear drum with the scanning head inside. The Hasselblad/Imacon desktop scanners scan the film on a curve and produce exceptional results from all formats. Dedicated 35mm film scanners can be used for batch scanning uncut 36-exposure films or stacks of 35mm mounted slides. The downside of batch scanning is that auto exposure can produce bland results especially from high- and low-key images – any image that is out of the ordinary will need individual exposure adjustment.

It is always best to scan to 16-bit resolution rather than eight-bit, particularly if any work is to be done later in an image editor. A conventional 35mm negative (24mm x 36mm) scanned at 4000 pixels per inch (ppi) is capable of producing a quality 18 x 12in inkjet print from a 40Mb greyscale file.

Digital scanning provides the opportunity to spot and remove dust and blemishes far more easily from film. Some scanners have dust and scratch reduction software, though tests will need to be done to make certain it does not create visible artefacts. The Digital ICE software bundled with many scanners can clean up scanned film dramatically. Some noise reduction software can be used specifically to reduce the appearance of film grain. Sharpening is necessary but needs care to produce clean, artefact-free prints.

Obviously, any film original can be used for scanning in black and white, though some films do seem to scan with more pleasing results than others. One observation is that film with a strong grain structure (usually older types of emulsion) scans better than do some of the modern tabular grain films. It depends a lot on the scanner and scanning resolution used, on personal preference and workflow.

Colour negatives are a good source of wide dynamic range black-and-white images but need careful adjustment to produce images with punch. Chromogenic black-and-white films scan particularly well. Colour slide film has a limited dynamic range and, with its dense black shadows, is harder to scan than colour negative. However, some of the colour slide films seem grain free (having no retained silver) and scan well to give particularly smooth tones.

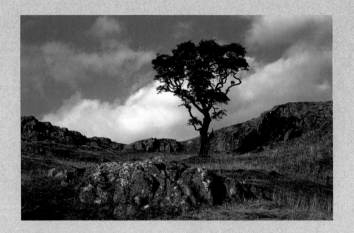

**Walltown tree (above)**

Though a colour transparency film, Velvia's effectively grain-free emulsion proves a good material to scan and produces super-smooth greyscale conversions.

**Photographer:** David G Präkel.

**Technical summary:** Leica R8, 60mm f/2.8 Macro-Elmarit, exposure not recorded, Fuji Velvia 50, processed by author in Tetenal E-6 chemistry. Greyscale conversion in Photoshop, sky and foreground/tree treated separately.

# Local exposure control

### Darkroom

There are many times when an exposure that suits the overall look of an image will cast some details into shadow or lose some highlight detail. The overall exposure can be adjusted locally. Increasing the exposure in one small area will darken that area of the print and bring out highlight detail. Casting a shadow over another part of the print will effectively reduce the exposure received by that area. This can bring out shadow detail. Skies often need an extra few seconds under the enlarger to darken them; faces can benefit from gentle dodging to lift them out from the image.

Reducing the exposure to lighten an area is called 'holding-back', or more commonly 'dodging'. Increasing the exposure is called 'burning-in', or more simply just 'burning'. The darkroom tools are the dodger and the burning board – or the photographer's hand – used to cast shadows to dodge or let light through between the hands to burn in (these have become the symbols for the Dodge and Burn tools in Adobe Photoshop).

Successful control of local exposure depends on accurate testing. It may be necessary to produce a range of test strips to establish the correct changes from the overall exposure in various different areas of the print.

There are obvious physical limits to the size of an area in an image that can be successfully dodged or burned without the effect being apparent. Some photographers are happy to have an exaggerated dodge or burn effect show in their final print to underline the photographic artifice. It is best to limit dodging and burning to larger areas in the darkroom and to blend the effect subtly. Dodging and burning is a very physical activity enjoyed by many darkroom workers as it gives a real feeling of interacting with the image-forming light. Enlarger foot switches can be obtained so that both hands are free to dodge and burn.

Dodgers can be bought but the best are home-made tools made from thin wire with Plasticine or Blu-Tack, which can be moulded into any shape and supplemented with bits of blackened card or aluminium foil. The burning board is a piece of card with a roughly made hole. Many workers prefer the flexibility of the human hand. The closer to the lens you work, the bigger and softer the shadow. You must keep the dodger or burning board moving to successfully blend the altered area into the overall image.

A final trick with black-and-white prints of a larger size is to 'edge burn' the print. A little extra exposure is given to the edges of the print to bring the viewer's attention into the picture when the large finished print is hung on display.

2 sec    4    6    8    10    12    14    16    18

A simple test strip in two-second increments establishes the correct exposure times for the bus body (ten seconds) and for the grassy area in front of the bus (eight seconds).

4 sec        8        12        16        20

A separate test strip with four-second increments is done for the small triangle of sky. This establishes a subjectively correct exposure time of 16 seconds.

The final print could be made in one of two ways. An overall exposure of 16 seconds given with the shed and bus dodged for six seconds (16 minus six equals ten seconds) and the grass for eight seconds (16 minus eight equals eight seconds).

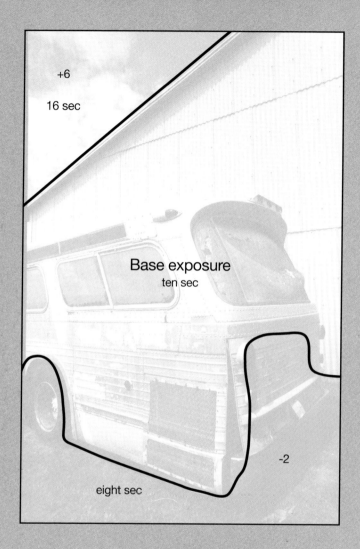

+6

16 sec

Base exposure
ten sec

-2

eight sec

As shown in the 'plot', it proved more convenient to give the image a ten-second overall exposure while dodging the grass for two seconds and burning the sky for an additional six seconds. A piece of card was cut to cast a shadow to include the wheel arch in order to differentiate the tyre from the deep shadow of the wheel arch. The back of the bus was dodged with a softer shadow made by a finger end close to the enlarger lens. A card with a straight edge was then used to burn the sky for a further six seconds. Darkroom workers will keep plots of dodging and burning to enable them to recreate a fine print later.

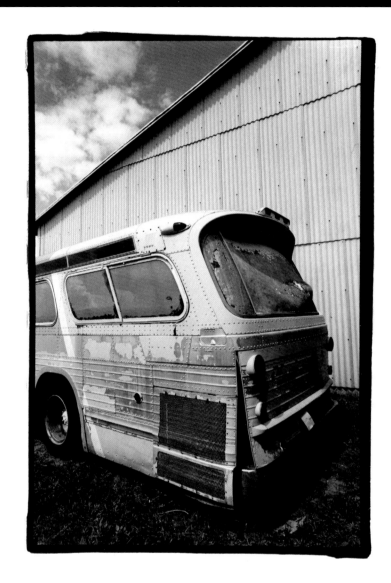

**NY Museum of Transportation (above)**

Greyhound bus awaits restoration.

**Photographer:** David G Präkel.

**Technical summary:** Leica R8, 24mm f/2.8 Elmarit with Red 25 filter, exposure not recorded, Kodak TMax 100 developed in Kodak D-76. Final print on Ilford Mulitgrade Warmtone pearl finish.

**Digital**

Of course, adjustment layers can be used to darken or lighten larger areas of a digital image. However, the real power of image-editing software is the ability to dodge and burn much finer detail than is possible in the wet darkroom and without the time limit imposed by the exposure.

The icons for the Dodge and Burn tools in the Photoshop toolbox imitate the hand and dodger employed in the wet darkroom. However, in earlier versions of Photoshop these tools were not a first choice as their operation was far from non-destructive (the main objection is that they change the hue, but this is not relevant to work on greyscale images). Advanced workers use a layering technique for local exposure adjustment that does not change the pixels in the original image. The dodge and burn layer can be stored as a reference and its effects adjusted through use of the Layer Opacity slider.

Some workers create separate dodge and burn layers but the following combined technique can be adapted (initial set-up is ideally recorded as a Photoshop action). From the main menu, (not the Layer pop-up) choose 'New Layer'. In the dialog box that follows choose a Soft-Light layer from the 'Mode' pop-up, named 'Dodge and burn layer'. Make sure the box for 'Fill with Soft-Light-neutral color (50% gray)' is checked.

In the Layers palette, a mid-grey layer appears over the background image but has no effect whatsoever. If this layer is altered from mid-grey towards black it will darken the image beneath; if it changes towards white, it will lighten the image. Using a brush set to 10 per cent opacity you can draw on the Soft-Light layer in white or in black to dodge and burn respectively. To erase work, simply sample the grey and overpaint the black or white mistake. If the effect is too distinct, you can blur the layer or parts of it. If the effect is in the right place but too strong you can use the Opacity slider in the Layers palette to mitigate the effect.

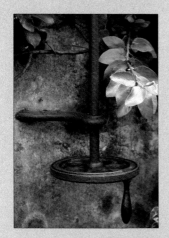

Parts of this layer were selected and blurred using a 25px Gaussian blur. Dodging and burning on the winder was left crisp.

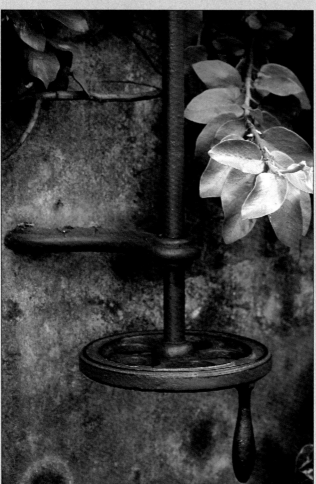

**Glasshouse winder (left)**
Original image (above left) plus the dodge and burn layer (above right) produce the final effect (left). The image can be stored as a layered file or a flattened output version created for printing.
**Photographer:** David G Präkel.
**Technical summary:** Nikon D100, 60mm f/2.8D AF Micro, 1/60 at f/5.6, ISO 200 greyscale conversion digital only in B/W Styler.

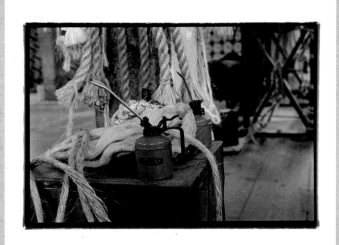

**Ropehouse (above)**

RC paper (top) is neutral and has an immediate impact, bristling with detail and with a wide tonal range. FB paper (bottom) has very rich, dark tones, the creamy paper support and warmer, browner emulsion contributing to this. The tonal quality and unglazed finish give the eye time to explore the print. In contrast, the RC print can seem a little frantic.

**Photographer:** David G Präkel.

**Technical summary:** Leica R8, 35–70mm Vario–Elmar–R, Kodak TMax 400 developed in Perceptol. Both prints made on Durst M670 enlarger with a Nikon EL-Nikkor 50mm f/2.8 lens. The two papers Ilford Multigrade IV RC Deluxe and Ilford Multigrade IV FB Warmtone required different exposures to achieve comparable prints. They were judged by test strips. The chosen contrast grade was #4 for both papers.

# Paper choice

### Darkroom
As with film, the rise of digital imaging has reduced choice among darkroom photographic papers. The principal choice is now between resin-coated (RC) or fibre-based (FB) papers.

Resin-coated papers are much more convenient to use than fibre but are rejected by the fine-art photographer. RC papers are made with the paper as the 'filling' in a polyethylene plastics sandwich. As the paper is not wetted during processing, washing can be very fast – sometimes as quick as 120 seconds. These papers dry flat and quickly, with hot air if need be. You would not use RC papers for exhibition prints or glossy RC images framed behind glass.

Fibre-based papers are the choice of the cognoscenti. The structure of the fibre base shows through the emulsion coat. This gives a character to the paper not seen with glossy RC papers. A high-gloss finish cannot be achieved with fibre prints unless they are ferrotyped (dried in contact with a highly polished metal plate). FB paper takes longer to soak up the processing chemicals and so takes longer to develop (which does give the photographer minute control over image density). Chemical carry-over can be an issue and washing the paper clear of fixer takes over 30 minutes (for only a ten-year print life). Archival processing of FB papers means two-bath fixing, hypo clear and careful washing in running water.

Both FB and RC papers are available with variable-contrast emulsions and in a variety of weights, though most RC papers are medium weight. Double-weight FB papers are a joy to handle but must be air-dried, face down on a chemically inert mesh to keep the prints flat.

The colour of the paper base may be quite cream or yellow, rather than neutral white. The biggest range is available in FB papers. This is in addition to the 'colour' of the emulsion. Chloro-bromide papers that have brown blacks are referred to as 'warm' tone; bromide papers with their blue-black emulsions as 'cool'. There are also neutral toned papers.

Developer choice can have an effect and exaggerate the 'look'. Both warm- and cool-working developers are available. The top coating of photographic paper can be given a finish, from glossy through semi-matt to matt, or they can be textured as with lustre and smooth-lustre papers. Choice depends on how they are to be exhibited or used.

Specialist papers for platinum and palladium (Pt/Pd) printing cannot be bought ready-made and are coated by the photographer themselves before printing. Quality artists' watercolour paper is used as a fibre base for coating.

**Digital**

Most people have put a piece of cheap 'office photocopier' paper through a photo inkjet printer; probably on the off-chance it might be a cheap proofing alternative. The results are usually a soggy or crinkled mess with unpredictable colour and blurred detail. Inkjet papers are not quite as simple as you might think. Though they have no real chemical activity, they do play a major role in providing the right degree of absorption for the printer inks and the right pH conditions (acidity/alkalinity) for the inks. Although many people are loath to spend the money on manufacturers' inks and papers, it must be said that, within a limited range of choice, you are buying a printer/ink/paper system and not just a printer.

A drop of ink will spread further on blotting paper than the same drop would on a piece of card. The final size of the area that is covered by each 'dot' of ink is important to the final look of the finished inkjet print. The surface of some inkjet papers is micro-coated. Some manufacturers use starches, others what are described as ceramics (china clay, in fact) or silica to control the way in which the individual ink droplets spread when they soak into the paper. Some papers are instantly dry with the ink trapped in an absorbent surface coating. Some papers swell and need a day or two to dry.

The quality of a black-and-white print from a CMYK inkjet printer will depend on how linear the mix between the cyan, magenta and yellow inks is across the tonal range. If ink coverage is not exactly even, the finished print will have one or more colour casts in different tones. The best black-and-white digital prints come from printers with dedicated neutral or toned black inks.

Very few inkjet papers look like a darkroom print; Lyson Darkroom Premium Gloss was possibly the first exception and has the look and feel of a traditional print. Harman technology Ltd (the company behind Ilford Photo) now offers the same fibre paper base with the baryta whiteners used in their traditional darkroom photo papers in a version for inkjet printing as Matt FB Mp Warmtone. This matches their Multigrade FB Warmtone paper. Photographers can now successfully mix darkroom and digital prints on these papers in the same exhibition.

The range of paper finishes is extraordinary, from rough art papers to pure matt whites, from silk and satin finishes to heavy lustres and canvas finishes. Some papers claim archival stability of paper colour and ink fastness to light, other papers fade visibly in days.

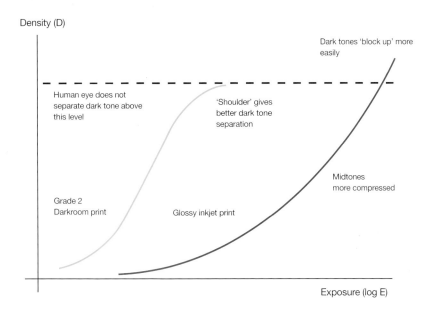

Density (D)

Dark tones 'block up' more easily

Human eye does not separate dark tone above this level

'Shoulder' gives better dark tone separation

Midtones more compressed

Grade 2 Darkroom print

Glossy inkjet print

Exposure (log E)

## Comparison of darkroom and inkjet papers

Multigrade resin-coated glossy darkroom print (below left). Inkjet print from Epson 2100 on Lyson Darkroom Semi-gloss (below middle) and Epson Archival Matte (below right). Note the limited black density of the print on matt paper. As the graph above shows, inkjet papers and darkroom papers differ fundamentally in how they 'carry' an image. Which is 'better' is not the question. Darkroom prints match the contrast of traditional film. Digital prints can have a greater maximum density but the shadows can block up easily. Black-and-white digital prints can compress midtones and can look 'muddy' without care.

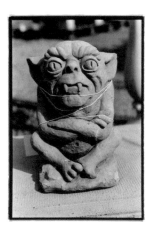

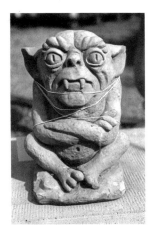

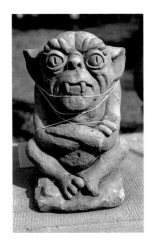

## Contact printing

Old photographically reproduced postcards often show exquisite detail. If the glass-plate negative from which they were produced was well exposed and in complete focus, then there is an almost perfect transference of image detail to the photographic paper (the surface of the postcard). This is because the negative that produced the card was not optically projected or enlarged in a photographic enlarger. It was instead put into direct contact with the photographic paper to make the positive image. No lenses – no losses!

The image-carrying emulsion of the negative is placed in direct contact with the positive image-forming emulsion. Negative and positive are kept in close contact with a weighted or spring-loaded piece of glass to make the printing exposure. It is from this process that the name 'contact print' derives. Large contact prints of course require large negatives in this one-for-one process.

Contact prints are made in a split-back contact printing frame that guarantees even and continuous pressure to keep the negative and printing medium in intimate contact. This can be achieved with a sheet of thick, heavy glass but imperfections in the glass can mar the finished print. This sandwich is then exposed to a controlled light source to make the positive image, which is then developed in the conventional manner.

A venerable alternative to conventional photographic paper is POP (printing-out paper). First sold in 1885, POP is a photosensitive paper where the image darkens fully during exposure – developing is not required. The image is made permanent by fixing in normal fixer. POP is now only available from one manufacturer and is a gelatin silver chloride paper produced with an excess of silver nitrate. It is slow working and does not need safelight conditions. It does, however, need a UV-rich light source for exposure. The paper darkens and the image appears during exposure, which makes it easy to judge the process by eye. Traditionally the images are gold-toned for longevity and for aesthetic considerations, shifting the image from chocolate brown to an aubergine (eggplant) colour that is not unlike that seen with excessive selenium toning.

Bostick & Sullivan, traditional-style spring back contact printing frames.

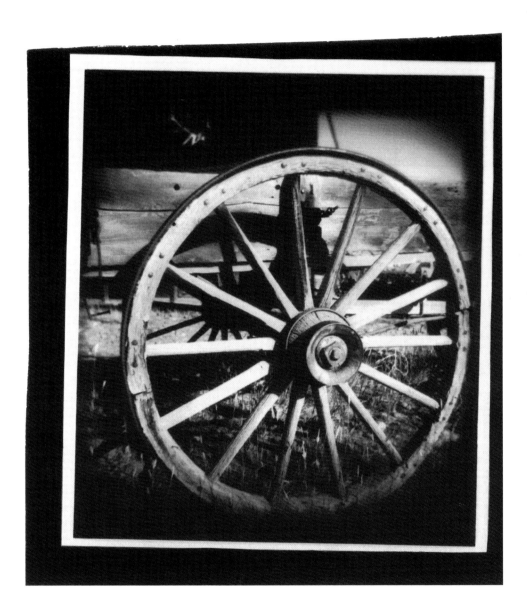

**Wagon wheel, Cody, Wyoming (above)**

The original roll-film 6cm$^2$ negative was scanned and a slightly larger acetate digital negative produced. The printing exposure was 'five minutes of full August Colorado sun at 5:00pm'.

**Photographer:** Jeff Wagner.

**Technical summary:** Holga, Ilford FP4 Plus, Bostick & Sullivan POP paper, no toning.

## Digital negatives

One of the most exciting crossover areas between digital and traditional photography is the production of digital negatives for the wet darkroom. Large digital negatives can be used for contact printing on to a range of photo papers and used in alternative processes. Platinum and palladium prints, large-scale cyanotypes and **van Dyke brown** prints can be produced more conveniently and the negatives easily fine-tuned with Photoshop curves.

Large pieces of film are expensive and difficult to handle for processing. Inkjet printers can cheaply and easily print negatives on to large sheets of clear acetate or white high-gloss plastic film. Some workers use the film output from an imagesetter. This offers resolutions up to 4800dpi and a media width of over a metre on some machines. Print shops running imagesetters are getting harder to find as more and more printers use platesetters which image directly to the printing plate without an intermediate film stage. Small test negatives should be produced to check maximum density.

One advantage of the inkjet route is that there is no dependency on an outside agency or equipment. Inkjet negatives can also be produced with spectral as well as physical density. It can be difficult to achieve sufficient density with black ink but printing in the same colour as safelight orange/red makes the negative more opaque to the printing paper than the physical light-blocking characteristic of black ink alone would. The major advantage of using digital negatives is the ability to retouch detail and easily change image contrast to suit different printing papers.

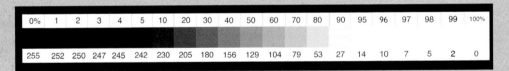

| 0% | 1 | 2 | 3 | 4 | 5 | 10 | 20 | 30 | 40 | 50 | 60 | 70 | 80 | 90 | 95 | 96 | 97 | 98 | 99 | 100% |
|---|---|---|---|---|---|---|---|---|---|---|---|---|---|---|---|---|---|---|---|---|
| 255 | 252 | 250 | 247 | 245 | 242 | 230 | 205 | 180 | 156 | 129 | 104 | 79 | 53 | 27 | 14 | 10 | 7 | 5 | 2 | 0 |

**It is useful to include a step wedge in the digital negative to give some means of measuring real densities which are given here in percentages and 0–255 greyscale levels.**

**Mission Concepción, San Antonio, Texas (facing page)**
Digital negative and van Dyke brown print. Final print shows attractive over brushing of photosensitive solution.
**Photographer:** Gary Nored.
**Technical summary:** Pentax KX, Pentax SMC 50mm f/1.2 exposure 1/60 at f/11 to place the deep shadow areas in Zone III. Negative printed on clear Pictorico film on Epson inkjet printer. Final van Dyke print contact printed onto Fabriano Artistico paper.

**van Dyke brown** alternative photographic processing using iron-silver chemistry to produce brown prints similar in colour to artists' brown oil paint, named after the Flemish painter, Sir Anthony van Dyck

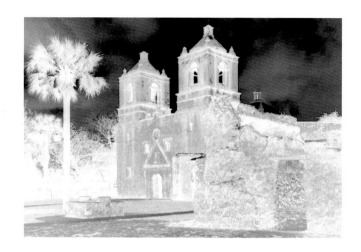

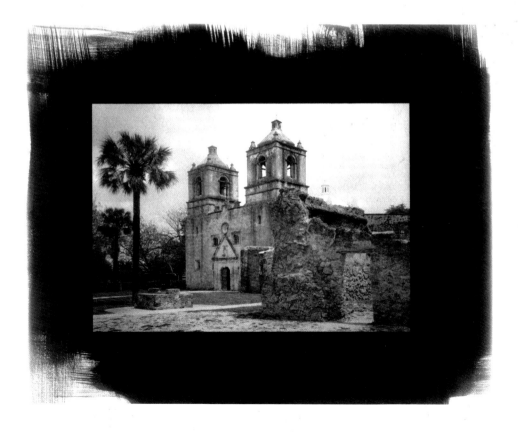

## Liquid emulsion

Photosensitive materials comprise a photosensitive coating, usually a dried emulsion applied as a liquid, on a clear base layer or carrier. A 'glue' is used to stop the photosensitive coating from flaking off and is known as the 'subbing layer', usually comprising hardened gelatin or a mix of gelatin and a water-based adhesive like PVA. Liquid emulsion is one of the easiest and most enjoyable alternative black-and-white processes as the chemistry is already done for you – all you have to apply is the emulsion and your imagination to the combination of image and receiving surface.

Glass and paper were the original carriers until the development of flexible films made initially of cellulose nitrate (which was flammable) and latterly, stable cellulose triacetate. Other materials like polyester are used for specialist purposes. However, the photosensitive mixture of silver halides and gelatin does not have to be applied to a clear flexible film.

Photosensitive emulsions are available as liquids for application to alternative surfaces. These go under trade names such as Liquid Emulsion or Liquid Light and need to be applied to a suitable carrier in darkroom conditions and dried before they can be exposed and developed in conventional paper developers. It is even available in variable-contrast formulation.

**Marguerite, Sandwich Beach Installation (2006) (above)**
Photographic image created with liquid emulsion on rock (a petrograph) contrasting fleeting human memories with the vastness of geological time.

**Photographer:** Pamela Petro.

**Technical summary:** liquid emulsion image of the artist's friend (from 1988) on 8 x 10in pebble from Sandwich Beach, Cape Cod prepared in darkroom and returned to the sea where it was found.

**Cabinet (above)**
Liquid emulsion image on wooden door panel and cabinet created from finished door panel.
**Photographer:** Marcy Merrill.
**Technical summary:** None supplied.

Exposure can be by enlarger or even a slide projector for bigger objects, using conventional or manipulated black-and-white negatives. Suitable surfaces could be papers and cloths but some workers experiment with wood, metals, plastics, even formed glass, rock and bricks. The trick is finding a suitable subbing layer to bind the liquid emulsion to the substrate. A small additional piece should be coated and dried for use as a test strip to establish the correct exposure. Consideration needs to be given as to how the developer and fixer will be applied and it may be decided to spray or sponge the item rather than immerse it.

Fresh from the bottle, liquid emulsion can be slow working and have reduced contrast. To compensate, some workers will add a very small and carefully measured quantity of paper developer to the liquid emulsion just before coating. In the end, it is not only the choice of object and surface that marks out the finished item, but the image chosen to be printed on that surface and the manner in which the light-sensitive emulsion was applied: smoothly or roughly.

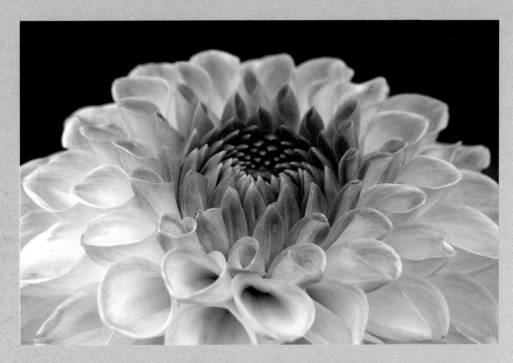

# Colour to black and white

It would seem to be a simple matter to create a black-and-white image from a digital colour file. Taking the colour away by desaturating the file does create a greyscale image but it is usually unsatisfactory. It will not match how we perceive the brightness of colours. Despite this, this method is still regularly recommended as a quick technique to create greyscale images in Photoshop or other image-editing software. Image > Adjustments > Desaturate, or pulling the Saturation slider over to -100 in the Hue/Saturation dialog will show this effect. It seems to work for colour images but you can see what happens to the spectrum and RGB colour swatches in the figures on pages 146–149.

There are two ways to approach a greyscale conversion. One is the subjective, 'to taste' route. Here colours are remapped to grey tones to produce an effect that the photographer finds pleasing. Colours that appear darker in the original can be made to appear lighter in the greyscale version. The overall look can be darkened or lightened. Contrast effects that would be difficult or even impossible to achieve in the darkroom can be applied. Toning too need not imitate existing chemical techniques but can use any intensity of any colour.

The alternative approach is to closely imitate the look of an existing film. You can make the image appear to have been taken on a particular kind of film with its characteristic grain, contrast and spectral sensitivity. You can even make it appear as if the film was developed in a particular way, then printed and toned using traditional darkroom techniques.

There are different software products and techniques available, some offering both approaches, others a limited but highly accurate film look with little in the way of flexibility. Other products offer endless possibilities.

**Dahlia – Amber festival (facing page)**
Though the original colour image depicts the radiant energy of this decorative exhibition bloom, the black-and-white conversion has equal validity, showing better the flower's structure, its repeating patterns and textures.

**Photographer:** David G Präkel.

**Technical summary:** Nikon D100, 60mm f/2.8D AF Micro, 1/320 at f/9.5 ISO 200. Greyscale conversion through Adobe Lightroom.

## Greyscale conversions

The simplest conversion is to change the image mode (Image > Mode) from RGB to greyscale through the Image > Mode > Greyscale command in Photoshop. Say OK to the 'Discard colour information' dialog. This creates a very evenly toned greyscale conversion, as you still have no control over how the primary colours are combined to give a particular shade of grey. The Photoshop conversion to greyscale is said to be based on roughly 30 per cent of the red information, 60 per cent of the green and 10 per cent of the blue information.

If black means no light and white means full light, then shades of grey can be seen as being brightness, a lighter grey being brighter than a dark grey. Being able to precisely mix the primary colours to a particular shade of grey gives you much greater control over the colour to black and white process. This control is still a matter of taste and is not based on any optical or perceptual principle. Better control is provided by the Channel Mixer found on the Image > Adjustments > Channel Mixer menu in Adobe Photoshop. Choose a black-and-white output with the tick box marked Monochrome and be certain to select the Preview. You can take any percentage of a primary colour to add into the final mix. The contribution of the three channels should roughly add to 100 per cent. To create a darkened sky effect, let the red channel predominate. The overall balance of the image can be maintained with a slight adjustment to the Constant slider to compensate for the source channels adding up to more than 100 per cent.

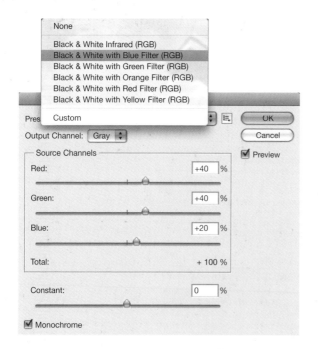

**Near Hector (facing page)**
Farm buildings at the roadside on Route 414 in the Finger Lakes, New York State, USA. The preview shows the black-and-white conversion settings and toning done at the same time.

**Photographer:** David G Präkel.

**Technical summary:** Leica R8, 35–70mm Vario-Elmar-R f/4 exposure not recorded, Kodak Elitechrome 100.

If you produce a 'look' that you like and would wish to apply to a batch of images in the future, do not forget to save the blend through the Save Preset… button in the Channel Mixer dialog. Photoshop will save this as a .cha suffix file in the Channel Mixer Presets folder by default. The Preset pop-up in Photoshop CS3 contains a set of basic conversions imitating the effects of film shot through various filters.

You can take more control of the separation and mixing of channels by using a little-known feature of the Channels palette pop-up, Split Channels. This creates individual greyscale channels for each of the red, green and blue channels in the original RGB file. Shift-dragging them into the same window will exactly align the channels as Photoshop Layers, one on top of the other. The final image can now be created using Layer Masks, Layer blending modes and Opacity, enabling you to choose shadow details from one source and highlight details from another.

Recent versions of Photoshop have included an Image > Adjustments > Black & white command that gives much greater control than the Channel Mixer over the conversion process. This dialog also enables you to choose a tint colour and saturation for the final black-and-white image at the same time. This now has to be the preferred easy method for converting legacy colour images to black and white in Photoshop.

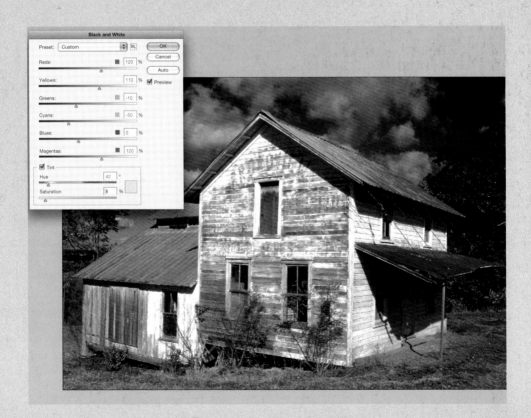

One of the most elegant black-and-white conversion methods was shown some years ago by Russell Brown of Adobe. Brown demonstrated a controllable monochrome conversion method using the Hue/Saturation dialog and Photoshop Layers. After opening an original colour file you wish to covert to black and white, you create a new Hue/Saturation Adjustment layer through the icon in the Layers palette (you can do the same using Layer > New Adjustment Layer > Hue Saturation…). You then remove all colour from the image by setting the Saturation slider to -100; as already discussed, this does not yet give a satisfactory greyscale conversion. It may help to name this layer 'Film' or 'Output' as this helps with understanding the method.

You must then select the Background layer and create a second Hue/Saturation Adjustment layer between the background and the first. It may help to name this layer 'False Colour' before changing the Blending mode in the Layer palette. It is important to set the layer blend mode of this adjustment layer to Color as this allows you to adjust the Hue of the underlying image that is desaturated by the topmost layer. Reopening the Adjustment layer dialog by clicking on the slider icon in the new layer gives control of the monochrome conversion process through just one slider. The Saturation slider in this 'invisible' layer can also be adjusted to finesse the final image; it acts to strengthen or weaken the effect from the chosen hue. You can see just what you have done by clicking off the visibility icon for the top layer; underneath, the adjustment layer will show the false colours desaturated by the topmost layer to give the black and white conversion. Saving the layered file as a work file gives you the opportunity to revise your conversion at any time in the future. Recording the creation and naming of the Adjustment Layers could be handled by a Photoshop Action to automate the process. This method offers a much more intuitive approach than the Channel Mixer.

**Beardless iris (facing page)**
Original image creates a very lacklustre black-and-white conversion though Image > Mode > Greyscale. Colour blended Hue/Saturation layer and Desaturate Hue/Saturation layer give control of black-and-white conversion though the creation of a false colour intermediate.

**Photographer:** David G Präkel.

**Technical summary:** Nikon D100, 60mm f/2.8D AF Micro, 1/250 at f/5.6, ISO 200.

Original image with HSL layer
visibility deselected.

Changing Hue, Saturation and
Lightness sliders while watching
the effect on the greyscale image in
the Desaturated HSL layer above.

False colour layer revealed when
Desaturated HSL layer visibility is
deselected.

It may be possible with some images to select one of the RGB channels, discarding the others, to create a greyscale image. Changing the image mode through the Image > Mode menu may give some hope of a quality greyscale image from the black channel of the CMYK mode but this channel is very light. It is equal values in the cyan, magenta and yellow channels that make up the bulk of the grey in the image.

However, converting the file to Lab mode separates out the **lightness** information (effectively the black to whiteness) from the colour or chroma information. The a and b dimensions of this model carry the red to greenness and blue to yellowness of the image respectively. It is interesting to look at the a and b channels separately to see how neither has any tonal value whatsoever. The Lightness channel looks better as a potential greyscale image than either the Desaturation or Convert to greyscale. However, it does not match exactly the perceptual performance of the human visual system, which is referred to as the **luminosity**.

The a (red to green) channel.

The b (blue to yellow) channel.

All the colour information is in the combined a and b channels of the Lab format.

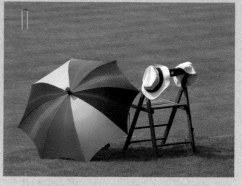

Original colour file.

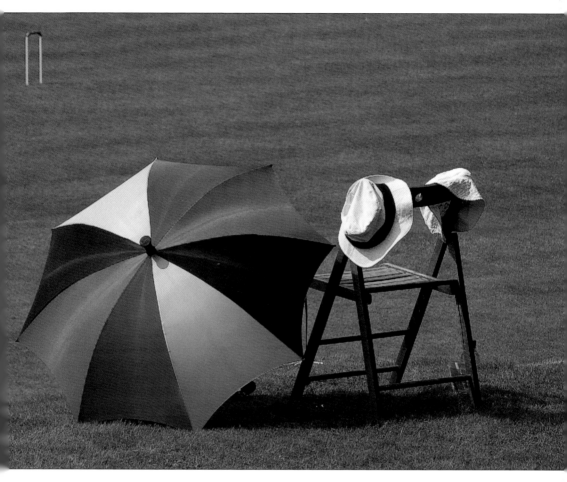

All the black and white information is in the Lightness channel.

## Croquet field (above and facing page)
Lab mode, original colour file, Lightness, a (red to green) and b (blue to yellow) channels.
Note the complete lack of tone in a and b channels.

**Photographer:** David G Präkel.

**Technical summary:** Nikon D100, 24–120mm F/3.5-5.6 at 120mm 1/350 at f/9.5, ISO 200.

**lightness** degree to which a colour appears to reflect light
**luminosity** intrinsic brightness (luminosity is not the same as luminance; it is not the luma component of a colour image; it is not the same as lightness; and is not the L in Lab or HSL)

Of the two types of cell – rods and cones – in the retina of the human eye, the cone cells are responsible for colour vision. There are three types of cell known as L, M and S for their sensitivity to long, medium and short wavelengths (red, green and blue light in other words). The cone cells are sensitive to a range of wavelengths and it is the combination of signals reaching the brain that carries the information about which exact colour we see.

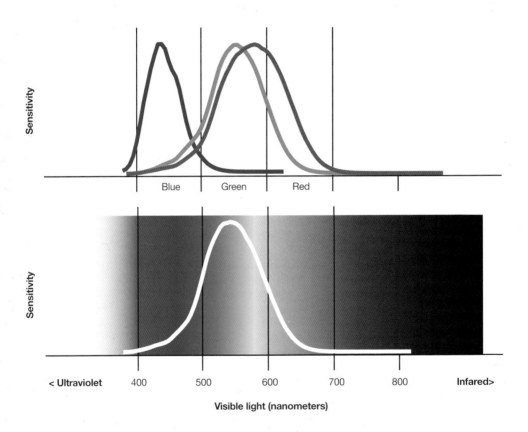

The top graph (based on data by Stockman and Sharpe (2000)) shows the relative sensitivity of each type of cone across the visible spectrum. The bottom graph (based on data by Sharpe, Stockman, Jagla & Jägle (2005)) shows how the combined output from the different cone cells contributes to our perception of brightness. Our eyes and brain are most sensitive to light in the yellow–green region.

### Lobster

There is one software product designed to reveal the true luminosity in an image. Though not primarily intended for producing black-and-white conversions, FreeGamma's Lobster does a first-rate job. Lobster is a 'droplet', not an application or plug-in. Working within Photoshop, it accurately separates the perceptual luminosity (the tonality as our eyes see it) from the red, green and blue **chromaticity** (the quality of colour, independent of brightness). As you can see from the examples, this is not the same as the Lightness channel of a Lab mode file. Neither is it anything like a desaturated or a greyscale mode conversion. Lobster's Luminosity channel is designed to mimic the perceptual colour priorities of the human eye and brain.

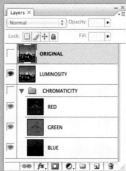

### Hook a Duck (above)

Lobster operates within Photoshop to separate luminosity and chromaticity components of an image. The original colour file can be seen as a thumbnail in the layer called 'ORIGINAL'. Visibility for Chromaticity layers has been deselected leaving only the LUMINOSITY layer visible.

**Photographer:** David G Präkel.

**Technical summary:** Nikon D200, 18–200mm f/3.5-5.6G VR AF-S DX IF-ED Zoom-Nikkor at 34mm, 1/320 at f/9.0, ISO 100.

**chromaticity** the quality of colour that is independent of brightness

**Adobe Camera Raw**

The Adobe Camera Raw plug-in, accessible through either Bridge or Photoshop, has now matured to offer sophisticated black-and-white conversion options. Recent versions have been able to apply adjustments through the Camera Raw interface to JPEG and TIF files as well as raw files. It is important to establish an accurate **white balance** before conversion to black and white, as a colour cast can affect the process. This can be achieved easily in Camera Raw and Lightroom at the same time as the file is converted.

The spectrum is divided into eight regions that can each contribute to the final greyscale mix.

**Split toning** can also be done in the same conversion process. The Hue and Saturation of the highlights and shadows can be independently adjusted as well as the balance between highlights and shadows. Sharpening, Vignetting and Luminance noise reduction commands are also possible.

**Adobe Camera Raw**

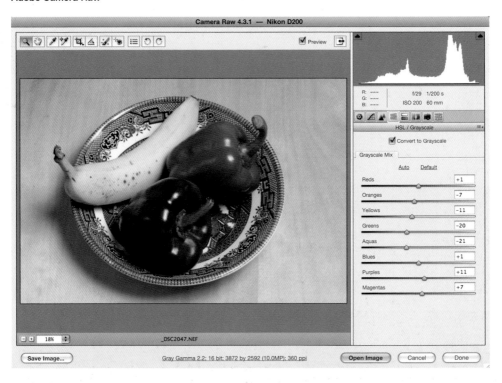

**white balance** adjusting for the colour temperature of the illuminating light, so white and neutral colours appear truly neutral and do not have a colour cast

**split toning** use of different colours or degrees of toning in highlights and shadows of an image

**Adobe Lightroom**

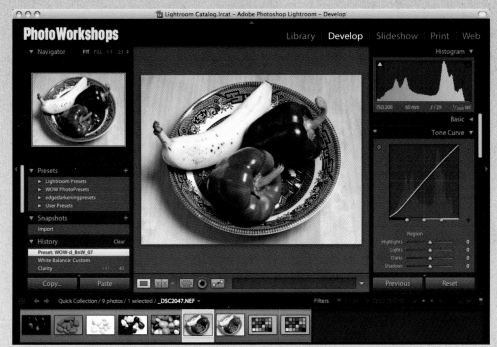

## Adobe Lightroom

Lightroom has all the flexibility of the Camera Raw settings for black-and-white conversion –
including on-hand White Balance – with the added advantage of Lightroom's interactive
Histogram and advanced Curve control. Lightroom generates an 'instance' of the raw data
according to the user settings. A copy of the file is opened, leaving the raw data untouched.
Snapshots of various 'looks' can be stored in Lightroom without generating a file for editing
at that time.

Lightroom ships with a set of standard presets that can produce attractive black-and-white or
toned monochrome images. Presets can be shared between users and downloaded. Check
the onOne software website for the downloadable set of 80 PhotoPresets with One-Click
WOW! by Jack Davis, which contains a set of 12 black and white presets and a preset to reset
the effect of any conversion back to colour. These are great greyscale mix starting points that
you can fine-tune.

Like Camera Raw, Lightroom divides the visible spectrum into eight regions. The Greyscale
panel also features an easily overlooked tool that allows users to click on any tone and drag in
the image to adjust the greyscale mix. In the Basic adjustments panel, the Clarity slider remains
active for greyscale conversions – this adjusts the micro contrast in the image to reveal texture
and give extra 'punch'.

# Products for a 'film' look

So far, all the techniques discussed are done 'to taste'. The following products set out to imitate the look of popular films by mimicking their contrast, spectral sensitivity and, in some instances, grain. If you are a black-and-white photographer who has worked with film or a newcomer who specifically wants to match the look of a known film stock, then these products are for you.

### PhotoWiz B/W Styler

B/W Styler from Harald Heim's plug-in site is available as a download or on CD. This is possibly the most comprehensive tool of all for those converting colour images, whether scans from film or digital originals. It supports both 8-bit and 16-bit RGB files.

It has an immense range of settings yet can be used by beginners or advanced workers with equal ease. It recreates films, lens filters, darkroom processing effects and photo papers as well as a massive range of subtle **toning** looks, soft focus or diffusion, and framing.

Photography Mode offers a single dialog with presets on pop-up menus covering black-and-white film type, ISO rating for grain, lens filters (colours, neutral density and diffusion), development strategy and special darkroom effects, paper grade, colour tone and a choice of framing or vignetting.

There are five generic film types and 15 known film looks including now-discontinued products such as Agfa Scala black-and-white transparency material. The list of toners is comprehensive: Bromoil, Collodion, Copper, Chrysotype, Cyanotype, Daguerreotype, Gold, Iron, Kallitype, Lead, Palladium, Platinum, Selenium, Sepia, Sepia Yellow, Sepia Red, Sienna, Silver, Silver Gelatin and Uranium.

All effects have their own separate adjustment panes. There are five additional special effect modes for doing special black-and-white conversions, including: selective black-and-white conversion, split colour, vignette blur and mist effects.

Expert users can get to grips with conversion sliders. B/W Styler even supports masking for selective control of the effects. A histogram, image information and help are provided as well as a split-screen preview.

**toning** chemically or digitally altering neutral grey tones. Brown, yellow or red-greys give 'warm' look while blue tones look 'cold'

**B/W Styler**

## Silver Oxide

In complete contrast are the high accuracy black-and-white Photoshop filters from Silver Oxide. The interface could not be simpler, with a choice of three common lens filters (with Wratten designations), control of the Brightness and Gamma (Contrast curve) and a very useful histogram. What is unusual is that you buy a single film look in each filter, though a general-purpose 16-bit landscape filter and Silver Infrared filter are also available. The filters are very easy to use and the conversion is uncannily like the real thing. If you really want a known film look and are not into tweaking, this is the product to buy.

**Silver Oxide**

## DxO FilmPack

The DxO FilmPack is available as a Photoshop (or DxO Optics Pro) plug-in and as a stand-alone application. It does much more than black-and-white conversion, imitating the colour and grain of over 20 films and cross-processing colour negative and transparency films. There are nine black-and-white films offered – all current film stock from Fuji, Kodak or Ilford. Six toners are available in the Colour modes dialog box; there are also settings for film grain dependent on the negative size.

It is simple to achieve good black-and-white conversions with the DxO FilmPack, though toning is not as subtle as with some other products. For people looking for a quick quality conversion and some good film looks beyond just black and white, the FilmPack can be recommended.

**DxO FilmPack**

## Power Retouche Black & White Studio

Power Retouche is a photo retouching plug-in specialist. Black & White Studio is described as a digital darkroom for black and white. Unusually, the plug-in also works with CMYK colour images that may make it attractive to professional photographers in a production environment.

Control is provided in four main areas: lens filters, film spectral sensitivity (from known film presets), the print, and through three selectable and independently adjustable zones. Seven black-and-white films are offered (three each from Ilford and Kodak, with the addition of the now discontinued Agfa APX 100) and two generic film looks (ortho- and panchromatic). Though not as comprehensive as some products, it covers most needs and importantly offers Perceptual Luminance as a conversion method. Beneath the film type presets, the spectrum is split into seven regions marked with the colour and the associated wavelength in nanometres. Filter strength and colour are continuously variable and user-selectable.

The Print pane gives useful control of exposure in familiar f-stops and contrast in Multigrade paper steps. Warm-to-cool toning is available through this pane but sadly, full toning (sepia, and so on) is handled by another plug-in from the comprehensive Power Retouche range that also covers the look of alternative processes like van Dyke brown and platinum printing.

Quite unusually, Black & White Studio provides anti-posterisation sliders that reduce the possibilities of banding or posterisation in the output, where contrast range is expanded.

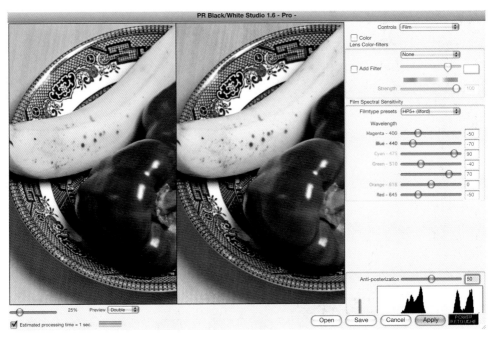

**Power Retouche Black & White Studio**

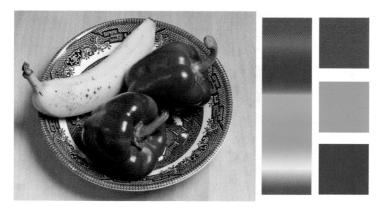

Original colour image, spectrum and RGB swatches.

Photoshop Desaturate. Note the complete lack of tone in the spectrum and the identical handling of the RGB swatches.

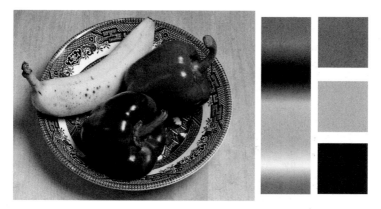

Photoshop Greyscale produces a far more satisfactory result, with the banana looking more natural.

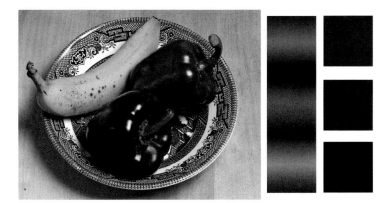

Photoshop Black & White set to automatic conversion; results are rather darker than greyscale.

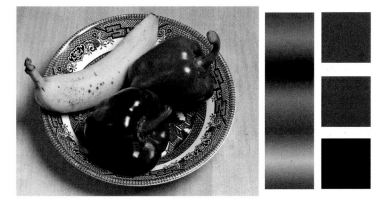

Photoshop Channel Mixer, 40 per cent red, 40 per cent green and 20 per cent blue.

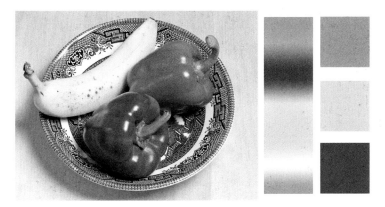

Photoshop Lab mode, Lightness channel after deletion of Chroma information in a and b channels.

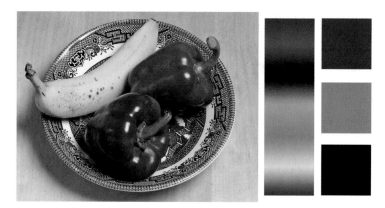

Lobster working within Photoshop to give true luminosity.

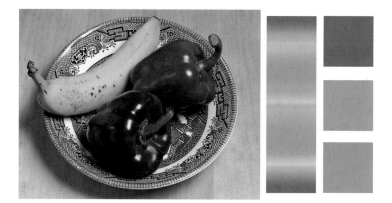

Camera Raw conversion to greyscale, set to auto.

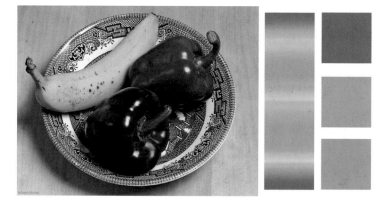

Adobe Lightroom; greyscale conversion set to auto gives almost identical results.

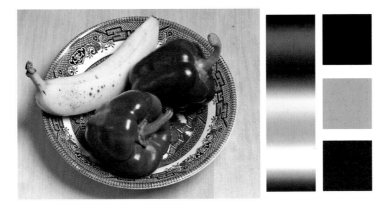

PhotoWiz B/W Styler, Kodak Tri-X conversion.

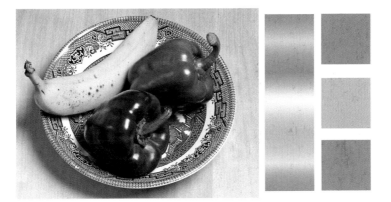

DxO FilmPack, Kodak Tri-X conversion.

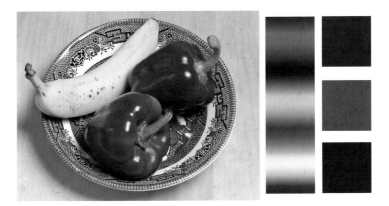

Power Retouche, Kodak Tri-X conversion.

# Black-only printing

If you experiment with any image-editing program that allows you to specify colour, you will find that if you enter the same number for each of the red, green and blue channels (or cyan, magenta and yellow channels for that matter) you will produce a neutral colour. A shade of pure grey is where all the numbers are equal, with RGB 0,0,0 being black (no light) and RGB 255,255,255 being pure white. Mid-grey is RGB 128,128,128.

In the same way, when it comes to printing with any CMY or CMYK system, a greyscale image can be reproduced using an exact mix of the colour inks, dyes or pigments. The catch is that exactly the right mix is required for each and every grey tone; if there is any slight variation in ink coverage there will be a colour cast over a range of tones that should otherwise be neutral grey. Additionally, some pigment inks show an effect known as **metamerism**. This means they look like different colours in different lights. Therefore, what looks like a neutral greyscale print from a colour inkjet printer in one light can show an unpleasant colour cast under different lighting conditions.

There have been two solutions to this problem. The first was to replace the colour inks in a printer completely with a range of dark and lighter neutral inks. Additionally, neutral inks, to which small amounts of colour had been added, could be used to produce warm (yellow/brown toned) or cold (blue toned) prints. The alternative and simplest solution was to use only black ink to print a greyscale image. However, this can produce a rather 'grainy' look, as greys have to be made up from a pattern of black dots on white paper.

Some printer manufacturers took note of these after-market inks and started to produce printers that featured three 'black' inks, each covering just part of the full tonal range.

With appropriate software (a **RIP** or **raster image processor**) a printer's performance can be optimised for black-only printing. The best known is Roy Harrington Quad Tone RIP, which can deal with a range of ink sets from both manufacturers and third parties. Neutral black-and-white images or warm-toned or even more strongly sepia-toned images can be produced from one image file.

**Black-only print of grey tone**     **CMYK print of same grey tone**

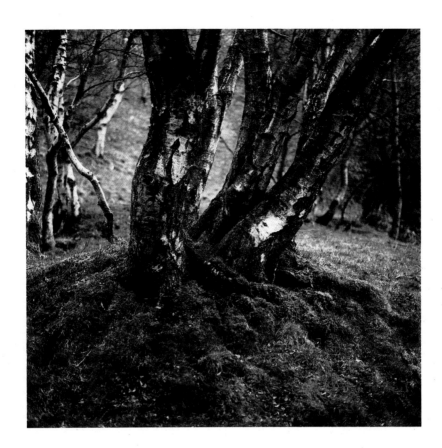

**Silver birch (above)**

Black-only print on fine art paper scanned to show texture. Permajet pigmented black ink at 1,440dpi on obsolete Epson 1200 printer.

**Photographer:** David G Präkel.

**Technical summary:** Mamiya C330, 80mm f/2.8, 1/250 sec at f/2.8, Ilford SFX no filter (rated at ISO 100) printed in black only on Lyson Standard Fine Art paper.

**metamerism** common short-hand form of illuminant metamerism, where a printed colour sample is perceived as having a different colour cast under different lighting conditions

**RIP** (raster image processor) software or hardware device that outputs a pattern of dots (halftone) for printing from a continuous-tone original

## The future

The story of black-and-white imaging seems to be turning full circle. Despite the freedoms and convenience of digital technology, there seems to be a hankering after the unrivalled qualities of the conventional silver gelatin, fibre-based black-and-white print.

Some of the impetus behind developing a traditional silver halide photographic paper for exposure in laser printers has come from well-established professional photographers. There has also been a steadily growing move against the inkjet print in the fine art and collectors' markets for black-and-white imagery. Gallery sales of inkjet-produced collector's prints from digitised classic collections have seen limited maximum prices where a darkroom handprint on silver gelatin, fibre-based paper would sell for much more. The limited resale price for a so-called **giclée** print is because of uncertainty about their longevity and archival qualities. They do not look like or feel like 'real' darkroom prints. In contrast, traditional silver gelatin prints are a known quantity, many having already been around for over 100 years.

The ideal would be to produce exhibition-sized, conventional darkroom quality prints but with the convenience and repeatability of digital printing. With this in mind, new black-and-white photographic papers have been specially designed for exposure in digital enlargers such as the Durst Lambda and Océ Lightjet. These enlargers are normally used to produce large colour photographs. Conventional black-and-white paper is sensitive to green and blue light only (variable-contrast papers rely on this fact). The new digital papers are coated with panchromatic emulsions that give increased red sensitivity, enabling them to take advantage of the three colour lasers in these professional digital enlargers.

Ilford Photo Galerie FB Digital is a fibre-based **baryta** paper for use in professional digital laser printers. After exposure, it is developed in normal paper developer, either in a processor or, in some instances, trays. For the moment, you can only get your images on to this material through a professional photo lab, as digital enlargers are very costly pieces of equipment.

**giclée** from the French verb, *gicler*, meaning 'to squirt'. High-quality, large-format inkjet print originally produced on Iris proofing printers; now in wider use in fine-art print markets to mean archival inks and papers. Originally used to avoid down-market connotation of word 'inkjet'

**baryta** barium hydroxide, used as a paper whitener under the photosensitive emulsion in fibre-based papers

**Arthur's seat (above)**

This image was part of a recent landscape exhibition in Edinburgh, Scotland; the first to feature digital silver halide prints – like this print – alongside the classic darkroom prints of master printer Ansel Adams. Such prints will become more common for both exhibition and resale purposes to collectors.

**Photographer:** Lindsay Robertson.

**Technical summary:** None supplied.

Putting colour back into a black-and-white image may seem an odd thing to do. Images in single colours other than black can have a strongly evocative quality; spot colours will stand out while hand colouring produces an attractive painterly quality. The following pages look at ways of reintroducing colour, either in the darkroom or digitally, using image-editing software or, where possible, in the camera.

There are two possible ways to put colour back. The first is to change the whole image from a true black-and-white print to an image based on another colour. The image remains monochromatic but the colour shifts from black to another colour. This may be the acceptable side effect of trying to preserve an image, as with archival toning. The toning process can be taken further to change the colour basis of the image. It may even be applied selectively so only certain grey tones of the original image are changed, which gives a split-tone effect. These effects are usually created by changing the chemical basis of the image or, less often, by dyeing the paper support.

Selective colouring is the second way. This can be done using a range of media including pastels, coloured pencils, dyes, inks and oil paints. Selective colouring gives the photographer the opportunity to reintroduce hints of the original colours or to introduce a completely artificial colour scheme. The bywords for success are subtlety and control.

Many computer effects for black-and-white images are copies of toning processes used with traditional silver gelatin prints. Most digital toning plug-ins will refer to sepia toning. Many will also imitate gold and selenium looks, others offering the difficult-to-achieve exotic colours from copper toning or the blues of some of the iron/silver toners. From that starting point there is no limit to what can be coloured or re-coloured using image-editing software. Garish colour schemes redolent of the primitive graphic arts effects of the 1960s are rather too easy to achieve. Sensitivity to the subject matter is advised.

Digital toning really scores in being able to imitate the look of what were once complex print-production techniques, such as the duotone and tritone.

**'You sepia-tone a bad print, and what you get is a bad sepia-toned print.'**
*Linda Cooley*

**Buffer beam (facing page)**
An industrial steam locomotive rusts quietly in the sun.

**Photographer:** David G Präkel.

**Technical summary:** Nikon D200, 12–24mm f/4 G AF-S DX (IF) Zoom-Nikkor (at 17mm), 1/200 at f/7.1 ISO100. Photoshop layered composite of strong black-and-white conversion and HSL-only-Red, done in Adobe Lightroom with PhotoPresets with One-Click WOW! by Jack Davis.

## Toning

Chemical toning has, and always has had, two distinct functions: to beautify and to preserve. With traditional darkroom materials, toning for either aesthetic or archival purposes is based on changes to the fundamental chemistry of the image. Though silver gelatin prints on high-quality fibre papers will last for many years, silver images can fade or discolour, especially when exposed to certain common chemicals or vapours. Gold toning was used in the past to achieve a more long-lasting print and to produce a very attractive red–brown image in place of the warm brown–blacks of the unprocessed image. Selenium toning is more commonly used today. This can be used in a very dilute form to prevent the photograph from ageing, with little or no apparent change to the colour of the image. At higher concentrations, or with longer processing, the silver print first changes to a graphite colour and finally to a distinctive purple grey/black colour often likened to aubergine (eggplant).

**Against the light – Borrowdale, Cumbria (above)**
Full sepia toning converts all of the image's tones to brown. The fully bleached print is redeveloped for a deep brown tone. Pulling the print sooner from the bleach will tone only the highlights, leaving other parts of the image brown/black.

**Photographer:** David G Präkel.

**Technical summary:** Leica R8, 35–70mm Vario-Elmar-R, Kodak T-Max 100 printed on Ilford Multigrade IV paper, Tetenal Sulphide toner.

The commonly recognised toning method associated in the public mind with 'old pictures' is of course sepia toning (though many older pictures described as 'sepia' are, in fact, gold toned). Sepia processing, unlike the single baths of gold or selenium toning, is a two-part process (all these toning processes can be done in daylight). The first step is to bleach the metallic silver image using potassium ferricyanide solution. The highlights of the black silver image are first to disappear. If this process is taken to its fullest extent, the whole image, including what were the densest blacks, will bleach back to be little more than a yellowish smudge on the paper. The image is still present (as a silver salt) on the photo paper but is no longer visible. A second bath completes the process by converting the silver salt into visible brown silver sulphide, redeveloping the image.

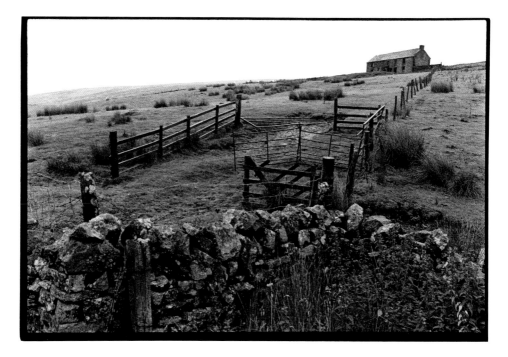

**Abandoned farm, North Pennines (above)**

Selenium toning adds strength to the darker tones and increases print density without affecting the highlights. The purply graphite colouration of strong selenium toning is an addition to this image.

**Photographer:** David G Präkel.

**Technical summary:** Leica R8, 19mm Elmarit-R f/2.8, exposure not recorded, Kodak TMax 3200 rated at 1600, developed in Fotospeed FD-10, printed on Ilford Multigrade IV RC paper developed in Ilford Multigrade and strongly toned in Fotospeed SLT20 selenium toner.

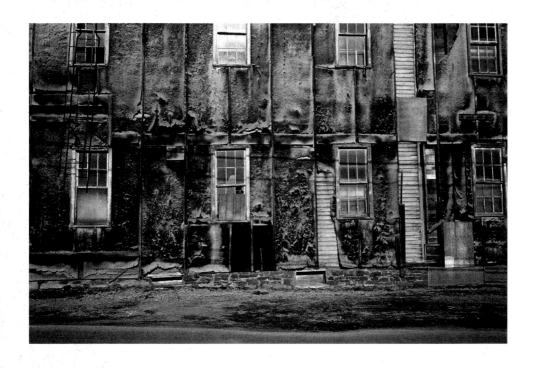

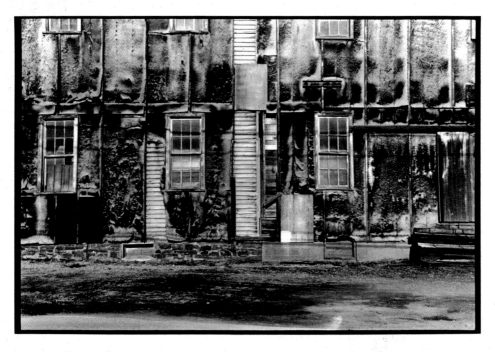

If bleaching was thorough, a completely brown image rapidly appears. If the image was only partially bleached, then the bleached highlights will reappear in brown, leaving the darker shadow details in the black of the original silver image. This is commonly referred to as split toning. The 'split' refers to the fact that parts of the tonal spectrum have been treated in different ways. With a fully sepia-toned print, you have a brown to dark brown monochromatic image in place of the black monochromatic image. With split toning, there is a mix of brown highlights blended through brown–black midtones to black shadows. The effect can be very attractive but is often something of a hit-and-miss affair in the darkroom. Workers may first need to experiment with a number of copies of the print and then batch process the remainder under precisely timed conditions to achieve anything like consistent results.

It is entirely possible to take split toning further to achieve effects that are even more pleasing. Toning the highlights with sepia, as described above, and then toning the remaining dark silver shadows with selenium will produce a very rich overall look to the finished print. In my experience, split sepia/selenium toning will consume even more prints before you get exactly the right combination and 'look' for a particular image.

**Navy Bean store, Pittsford, NY (facing page)**
Black-and-white original print and split-toned version in sepia and selenium. A number of prints were toned to produce the desired effect with brown sepia highlights and rich, deeper brown black shadows.

**Photographer:** David G Präkel.

**Technical summary:** Leica M6, 35mm f/1.4 Summilux, 1/250 at f/11–16, Ilford FP4 Plus developed in Kodak D76 1:1. Printed on Ilford Multigrade IV RC Glossy Sepia and Selenium toned.

Once you understand that toning is simply messing around with the chemistry of the silver image, you can see how other chemicals can be used to create a palette of effects from black-and-white prints. Copper toning gives a variety of greens but needs a subtle touch so as not to look garish or tasteless. Vanadium toners can produce yellows from the black–silver image and iron-based toners (including the famous Prussian blue) produce a wide variety of striking blues. Intense reds are hard to get and appear brick coloured or pale strawberry red. It should be remembered as well that some of these metal replacement toners actually shorten the life of the print.

Liquid rubber masking can be used to protect parts of the image while selectively toning parts of a print (as selective bleaching can be used to lighten other areas). Bleaching is often used by the advanced darkroom worker as an additional way to lighten or lift detail in a finished print. The effect is similar to dodging under the enlarger but has a cleaner, brighter quality. The bleaching solution is the same bleach used in the first sepia-toning bath, potassium ferricyanide, but in order to control its effect, it is mixed with fixer. It is perhaps more commonly known in the darkroom as 'farmer's reducing agent' or 'farmer's reducer'. The bleach is applied sparingly to a wet print with a brush or cotton wool bud. A hose of running water is held in the other hand to wash away excess bleach, thus stopping the process and preventing any runs from bleaching other parts of the print.

Palette toner is available in kit form, which, as the name suggests, enables workers to produce a variety of colours. Chemical solarising toners may also be obtained. These are used to reverse tones as in darkroom solarisation where light tones reverse after re-exposure to white light. With chemical solarisation, the colour is taken up by the white parts of the image, not the positive black silver image. Toning and solarisation can be done together. Effects can be very variable, with the length of time in each bath determining how strong the colours go and to some extent where the boundary is between the two colours in the image.

Dyes can be used to dye the paper material selectively or to give an overall colour cast. Even food dyes can be effective brushed on or more carefully applied over detail.

**New Bridge near Rosthwaite, Borrowdale, Cumbria (facing page)**
Black-and-white original print and solarised and toned version. Each attempt at this technique produces different densities of colour and different colour coverage. This print was more intensely coloured and showed a better colour of blue on the fell side and in the stones of the river than others processed at the same time.

**Photographer:** David G Präkel.

**Technical summary:** Leica R8, 35–70mm Vario-Elmar-R, Kodak T-Max 100, printed on Ilford Multigrade IV RC paper, Colovir yellow solariser and blue polychrome.

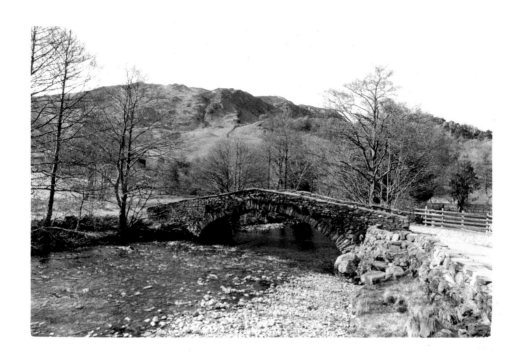

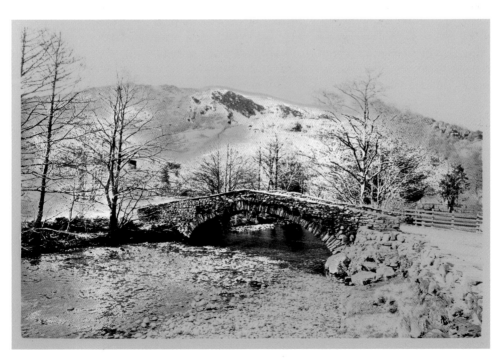

## Digital toning

One of the issues with digital toning is the consequence of the total freedom to choose colour and effects that modern photo image-editing software provides. Creative darkroom workers recognise the limitations of their traditional chemical techniques and work hard to get around or even pervert the craft process. But the starting points are known. The complete freedom offered in the digital domain can perversely pose a challenge.

Many digital photographers begin by imitating conventional wet chemical toning techniques, such as sepia and selenium. The digital darkroom can produce fine prints that imitate the look of conventional darkroom fine prints without involving any of the mess or poisonous chemistry. The results are accurate and, more importantly, repeatable. Once a black-and-white image is converted to an RGB or CMYK image, the individual channels can be adjusted with the Levels or Curves controls to tone or colourise an image. Colour Balance adjustments can also be used. Good effects can be saved for reuse as a settings file through any of these dialog boxes. However, the most precise and controllable digital toning effects are to be had from Photoshop actions or dedicated plug-ins such as PhotoKit from PixelGenius (PhotoKit intentionally imitates darkroom effects and camera filters on the computer that are familiar to traditional photographers).

Colourising is to take a true black-and-white image and change black for another colour. The image remains monochrome but the grey tones are substituted by tones of another colour. This can be done through the Colorize option in the Image > Adjustments > Hue/Saturation dialog box. Again, refinement and a respect for the subject are the keys to success. Blues are 'cold'; reds and browns are considered 'warm'. The best colourised images are based on a colour that is dark when used as a solid colour. A colour such as yellow produces very weak colourised images.

Advanced prosumer cameras, as well as simpler point-and-shoot types, usually offer a digital black-and-white mode on the camera. Though this mode has the advantage of showing you the exact effect you will get on the camera screen, while you are still in front of your subject, there are disadvantages. Digital in-camera black and white is just that. You cannot go back on your decision once you have taken the picture. With a colour digital capture, you have all the possibilities of different monochrome conversions that can be applied later on the computer and you retain the original colour image. That said, the one advantage of shooting black-and-white mode in the camera is that you do intentionally limit your options. This goes back to the comments made on pages 36–39 about the psychological advantage of having a camera loaded with a black-and-white media.

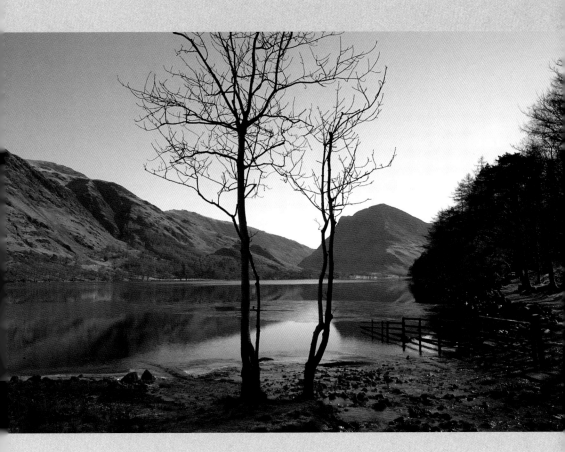

**Grassmere Winter (above)**

Palladium printing the easy way. Digital colour original converted to black and white and digitally toned to imitate a Palladium print. This look could of course be applied to a scanned film original to give it the appearance of this classic darkroom printing technique (see pages 164–165).

**Photographer:** David G Präkel.

**Technical summary:** Nikon D100, 18–35mm f/3.5-4.5D AF ED Zoom-Nikkor at 20mm 1/350 at f/8 ISO 200. with BW Styler set to imitate Panchromatic film with 200 speed film grain and a Palladium print contrast equivalence Grade 3 (the result is more contrasty than a real Palladium print).

## Duotones, tritones and quadtones

You may find the printed images in high-quality books of photographs described as duotones. This is done to enrich the tonal range of the printed images. This form of printing is the closest you will get to the look of a silver gelatin fine print. It costs more to print these images as, unlike conventional printing, it is not done simply with black ink on white paper. The duotone, as the name suggests, involves two inks. One ink is usually black (though this doesn't have to be the case), which carries the darker tones in the image. A second ink, usually a warm or cool grey, is used to reproduce the lighter tones. The combination of inks gives the printed images a greater tonal subtlety.

This printing technique can be further refined by the use of three inks – the tritone – or even a total of four inks to give a quadtone. An alternative to grey inks is the use of a coloured ink – often chosen from the Pantone range of spot colours – which can be used effectively to split tone the printed image on the page. All these techniques are used to overcome the limitations of the conventional, screened halftone printed in black ink. Some black-and-white images that appear in books produced using four-colour printing (CMYK) are given added richness by printing the black ink over yellow.

Adobe Photoshop is commonly used to prepare files for duotone printing. The image mode is unusual: unlike the three-channel RGB file, which will be three times the file size of a single-channel greyscale image or the four-channel CMYK file, which will be four times the size, a duotone is barely larger than the single-channel image. Surely it would be twice the size of a greyscale image as it would seem to contain two channels' worth of information? What it actually contains is a single greyscale channel but two transfer curves that control the density of ink relative to the various tones in the image. Thus a quadtone will contain the original image data and four transfer curves and will be a barely bigger file than a duotone.

Creating a duotone from a greyscale image is done through the Photoshop Mode menu. This opens a dialog box where the individual inks making up the duotone, tritone, or quadtone can be chosen and the ink coverage controlled through a graph similar to a Photoshop Curve. Presets for CMYK process colours and Pantone spot colours and warm or cool greys are provided or you can mix your own, taking care to achieve an even coverage over the whole tonal spectrum.

Though primarily a technique for high-quality magazine or book publishing, the look of a duotone can be had with conventional colour inkjet or thermal printers. The duotone EPS or Photoshop format file must first be converted to an RGB file through the Photoshop Mode menu; the exact effect will not be retained but test prints will enable good results to be achieved.

**Green Onions (facing page)**

Onions in a decoratively plaited string await their fate in a kitchen window.

**Photographer:** David G Präkel.

**Technical summary:** Mamiya Press Super with Mamiya-Sekor 150mm f/5.6 6 x 9cm Ilford HP5, scanned on Epson 4990 flatbed scanner, duotoned in Photoshop.

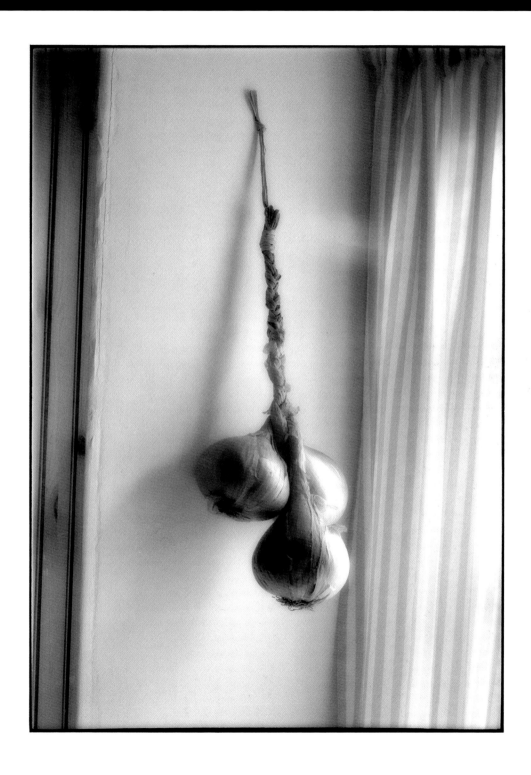

## Oils, pastels and pencils on prints

The simplest, and possibly the most satisfying, method of reintroducing colour into a black-and-white darkroom print is to hand-colour the print using oils, paints, pastels or dyes. Some of these media soak into the photographic paper, others are carried on the surface; some colour the existing image and others obscure parts of the image with solid colour. The choice of effect is yours. It is always worth experimenting (use your darkroom test strips) to see the effects before you commit yourself to begin work on a fine print.

You may wish to make prints specifically for hand colouring in the darkroom. While resin-coated prints can take water-based media, pastels and oils sit rather too clearly on the surface of a glossy print. It is far better to produce fibre-based prints for hand colouring, as colour can be worked into the depth of the paper where it becomes part of the image. A slightly paler print with a softer contrast grade than normal should be made for hand colouring, especially if colour is to be put into the dark areas of the image or a lot of colour carried. A little wetting agent can be used with water-based dyes to help penetration; with oils, artist's painting medium can be used to thin the paints to achieve the same effect and control the strength of colour.

There is absolutely nothing to stop the adventurous digital photographer from using true hand colouring on a toned or black-and-white digital print. In fact, some of the digital papers, especially the rougher surfaced fine-art papers, are more suited to taking colour from dyes, pencils, pastels and oils than darkroom papers.

Though coloured pencils can be used to hand-colour images, the graphite pencil is a powerful tool when contact printing paper negatives. Working on the back of an original print with a soft pencil will darken tones and can be used to increase tonal separation. A paper negative is generated by contact printing from this original print. Further pencilling on the negative will now open up the highlights when the finished contact print is made. Hand colouring this final contact positive can produce an image that looks more like a colour lithograph than a photograph.

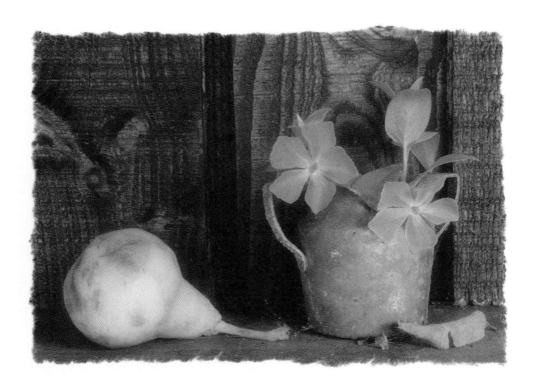

**Pear and Periwinkle (above)**

Good hand colouring requires a gradual building up of colour and lightness of touch.

**Photographer:** Kathy Harcom.

**Technical summary:** None supplied.

## Digital hand colouring

For digital hand colouring it is important to start with an original black-and-white image that shows a full range of tones and that does not have blocked up shadows. Ideally, the image should have no solid black at this stage.

This scan from a 35mm negative has been intentionally created for hand colouring; note the black point way off to the left of the image data in the histogram.

| Channel | Gray | ⇕ | ⟳ |
|---|---|---|---|

| Source | Entre Image | ⇕ |
|---|---|---|
| Mean: | 120.53 | Level: |
| Std Dev: | 92..77 | Count: |
| Median: | 115 | Percentile: |
| Pixels: | 326140 | Cache Level: 4 |

**Histogram of original image**

### Abandoned station wagon

Derelict car sits underneath a walnut tree on a ruined farmstead near Ovid, NY.

**Photographer:** David G Präkel.

**Technical summary:** Leica R4, 35–70mm Vario–Elmar–R, exposure not recorded, Kodak TMax 400, developed in Kodak D-76 1:1. Original negative scanned with Kodak RFS 2035 Rapid Film Scanner. Levels readjusted after colouring. The second image 'Leaves', which provided the colours for sampling, was taken on a Leica R4, 60mm f/2.8 Macro-Elmarit, 1/60 at f/2.8, on Kodak Elitechrome 100 Extra Colour film.

With the file 'Leaves' open in a window alongside the 'Car' window, I could sample colour by holding down the Alt/option key and clicking where a new colour was wanted for the hand-coloured image. If you find the colour image distracting you can reduce its colour palette to the 256 most important colours by converting the image to an indexed colour image using the Photoshop Image > Mode > Indexed Color menu. The settings Force Colors, None and Preserve Exact Colors seem to give the best selection. You can inspect the colour table through the Image > Mode > Color Table... menu. For convenience, you could use a screengrab utility to capture the Color Table dialog box and use this file as a simplified colour palette from which to sample your colours.

Colour must be built up using thin layer on thin layer and needs to follow the contours and shading of the original image. Do not over-paint. A pressure-sensitive pen on a graphics tablet is far better for this work than a mouse. Knowing when to stop is the real trick!

**Color Table dialog box**

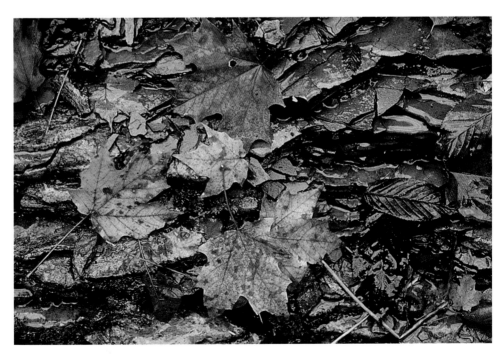

**The image from which leaf colours were sampled**

Convert the greyscale image to an RGB image through the Photoshop Image > Mode menu. You can now colour the image directly using a brush set to an appropriate size and to Color mode in the Brush Options. A low opacity works best; start with a setting around 20 per cent and experiment. Try overlaying colour on a variety of tones to judge the effect. A greyscale step wedge converted to an RGB file can be a useful place to experiment. For non-destructive colouring and greater flexibility, try working on a layer with its Blending mode set to Color using a Brush in Normal blending mode.

You may wish to pick your colours directly from the Photoshop Swatches palette. It is far better to sample and use real-world colours from a second image. My own method is to choose pairs of images for this technique: one in black and white for the image and one colour image for the colour palette. The subject matter of the colour image is usually irrelevant as long as the appropriate range of colours is present.

For the rusted car (used on page 86 in the companion title, *Basics Photography: Composition*), a palette of autumn/fall colours would be appropriate for the rusted metal. As the station wagon was once painted in light blue, these colours and foliage colours would be needed too. Looking through scans for colours, an image of wet leaves on slate was chosen as it could provide an appropriate range of mossy greens, russets, ochres, purples and blues.

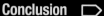

## Conclusion

Black-and-white photography begins with an extra degree of abstraction. For reasons of its aesthetics alone, in fine-art photography and for its authoritative tone in documentary work, it will never be replaced. At the beginning of the book, we looked at two communities of photographers. For one group, black-and-white film is the source of their understanding – both technical and emotional – of photography. For another group, black and white is a quick way to add some 'style' or 'mood' to an existing colour image. Hopefully, this book has shown that (pre)visualisation and 'seeing' in black and white can dramatically improve your photography in all respects, whatever medium you are working with: film or digital, in black and white or colour. Black and white represents a simpler way to work and consequently its message can be stronger and more honest or direct.

Though digital technology, with its ease and convenience, is sweeping away colour film, there is still a lot to recommend wet-film black-and-white photography to the photographer. Purists still working with traditional chemically processed black-and-white film can benefit later from digital in their workflow. Film scanning can produce high-quality digital files from vulnerable film. Advances in quality and the opportunity to work on small-scale enhancements of your images make digital printing an attractive alternative to wet darkroom techniques. Detailed retouching can now be achieved on scanned images from film that could not be dreamt of without digital technology. In the conventional darkroom there is a finite time – the length of the exposure during which all dodging and burning must be carried out – and a physical limit to the size of work that can be conducted. On the computer, no such limits exist. The finest detail can be treated to local exposure adjustment and worked on at any time.

It is hoped that this book has provided a good overview of the exciting possibilities of working with black and white. Each topic has its own specialist literature explaining the various crafts and techniques in depth. Be encouraged to explore.

## Contacts
Adobe Lightroom/Camera Raw
www.adobe.com/products/photoshoplightroom
www.adobe.com/products/photoshop/cameraraw.html

B/W Styler
www.thepluginsite.com/products/photowiz/bwstyler

Black & White Studio plugin
www.powerretouche.com

David G Präkel
www.photopartners.co.uk

DxO Labs - DxO Film Pack software
www.dxo.com/intl/photo

Catherine Forrest
www.trevillion.com

Kathy Harcom
www.kathyharcom.com

Ed Kashi
www.edkashi.com

Lobster
www.freegamma.com

Marcy Merrill
www.merrillphoto.com

Pamela Petro
www.petrographs.blogspot.com

PhotoKit
www.pixelgenius.com/photokit/index.html

PhotoPresets with One-Click WOW! by Jack Davis
www.ononesoftware.com

Silver Oxide
www.silveroxide.com

Nana Sousa Dias
photo.net/photodb/user?user_id=521294

Jeff Wagner
www.alternativephotography.com/artists/jeff_wagner.html

**Acutance**
Measure of the sharpness of a print or negative.

**Baryta**
Barium hydroxide, used as a paper whitener underneath the photosensitive emulsion in fibre-based papers.

**Characteristic curve**
Graph showing relationship between the amount of exposure given to a photosensitive material and the corresponding density after processing.

**Chromaticity**
The quality of colour that is independent of brightness.

**Chromogenic**
Photographic process using chemical couplers to create coloured or black-and-white dye images from the original silver image which they replace. Black-and-white film that is developed in colour chemistry.

**Contrast**
Difference in brightness between the darkest and lightest parts of the image.

**Contrast curve**
Image-editing software tool that allows selective adjustments of tones and overall contrast.

**Complementary colours**
Pairs of colours that lie 'opposite' each other on the colour wheel. A filter of one colour will darken its complementary opposite. These are not the same colour pairs as traditional artists' complementary colours.

**Cyanotype**
Photographic process using iron salts rather than silver. Monochromatic blue/white prints.

**DMAX**
Maximum density, not an absolute but varies from medium to medium.

**Emulsion**
Coating on film or paper usually comprised of gelatin with light-sensitive silver salts (halides).

**Exposure**
Combination of intensity and duration of light used to allow the right amount of light to reach film or sensor to record full tonal range.

**Fast and slow**
Subjective terms for film that reacts quickly or slowly to light (usually coarse grained and fine grained respectively). Fast means high, slow means low ISO number.

**Film grain**
Appearance in the final image of the individual specks of silver salt that make up the tones of the picture (see Noise).

**Film speed**
How 'quickly' film reacts to light – a measure of light sensitivity (see Fast and slow and ISO).

**Gelatin/gelatine**
Image-forming photosensitive emulsion layer – used by galleries to denote conventional black-and-white photographic print on fibre paper.

**Giclée print**
From French verb *gicler* meaning 'to squirt'. High-quality, large-format inkjet print originally produced on Iris proofing printers; now in wider use in fine-art print market to mean archival inks and paper. Originally used to avoid down-market connotation of word 'inkjet'.

**Graduated filter**
Partly toned resin or plastics filter with slightly more than half of the filter clear. Clear to grey area has a smooth transition. Used to darken skies or control contrast.

**Grey card**
Standard piece of card that reflects 18 percent of the light falling on it to provide an exact midtone light reading.

**Hard and soft**
Subjective terms used to describe high contrast and low contrast images respectively (also of photographic papers).

**Histogram**
A bar chart of frequency distribution showing how many pixels are found at each brightness level.

**Intensifier**
Chemicals used to improve the density of black-and-white film negatives. Usually coarsens grain structure but may make underexposed and underdeveloped negatives useable.

**ISO**
International Organization for Standardization – body that sets standard for film speeds and matching digital sensitivity. Measure of film speed or digital sensitivity.

**Latitude**
Degree of over- and underexposure film or digital sensor can accommodate and still provide an acceptable image.

**Light**
Spectrum of electromagnetic radiation visible to the human eye bounded by ultraviolet (UV) and infrared (IR).

**Light meter/exposure meter**
Measures intensity of light for photography, giving value as a combination of shutter speed and aperture or a single Exposure Value (EV) number for a given film speed or sensitivity.

**Lightness**
Degree to which a colour appears to reflect light.

**Luminosity**
Intrinsic brightness. (Luminosity is not the same as luminance, it is not the luma component of a colour image, it is not the same as Lightness and is not the L in Lab or HSL.)

**Metamerism**
Common short-hand form of illuminant metamerism where a printed colour sample is perceived as having a different colour cast under different lighting conditions.

**Monochrome/monochromatic**
Reproduction in the varying tones of only one colour (usually refers to black and white).

**Neutral density (ND) filter**
Filter that reduces light intensity equally across spectrum.

**Noise**
Out-of-place pixels that break up smooth tones in a digital image. Can be colour (chroma) noise or luminance (luma) noise or a combination.

**Orthochromatic**
Photographic emulsion that is sensitive to all visible colours except reds.

**Overexposure**
Images created with too much light, having no shadows or dark tones (see Underexposure).

**Panchromatic**
Photographic emulsion that is sensitive to all colours in the spectrum and sometimes beyond into the ultraviolet and infrared.

**Photosensitive**
Reacts to visible light (sometimes also to light above and below the visible spectrum UV and IR).

**Postmodern**
Decontextualising and re-contextualising styles; a mixing of styles of different eras, cultures and genres.

**Printing out paper**
Photosensitive paper where the image darkens fully during exposure – no developing is required, only fixing to make the image permanent – commonly called POP.

**Pyro**
Short form of pyrogallol (1,2,3-trihydroxybenzene) – photographic developing agent that causes staining in areas of heavy development producing negatives with fine tonality and clear highlight detail that are easy to print and scan (used also of pyrocatechin).

**RIP (raster image processor)**
Software or hardware device that outputs a pattern of dots (halftone) for printing from a continuous tone original.

**Split grade/split filter**
A method of printing using variable-contrast paper where two exposures are combined one at a low contrast and one at high. Properly done gives ideal contrast match for any negative

**Stochastic**
Having a random probability distribution – used of random texture screens for printing.

**Stop**
Photographer's unit expressing ratios of light or exposure where one stop represents a halving or doubling.

**Tonality**
Quality of tone or contrast.

**Tone**
Full range of greys from solid black to pure white.

**Toning**
Chemically or digitally altering neutral grey tones. Brown, yellow or red-greys give 'warm' look while blue tones look 'cold'. Archival treatment of silver gelatin prints.

**Underexposure**
Images created with too little light, no highlights or light tones (see Overexposure).

**van Dyke brown**
Alternative photographic processing using iron-silver chemistry to produce brown prints similar in colour to artists' brown oil paint named after the Flemish painter Sir Anthony van Dyck.

**Vignetting**
Light fall-off toward the edges of an image – sometimes a lens fault, sometimes done to 'age' the look of an image by edge burning.

**White balance**
Adjusting for the colour temperature of the illuminating light, so white and neutral colours appear truly neutral and do not have a colour cast.

## Acknowledgements

Thank you to Brian Morris at AVA for suggesting that I write this book; to Leonie Taylor for picture research and sourcing; Leafy Robinson for her overseeing and editing and fellow AVA author Steve Macleod for help with sourcing images.

Many thanks to the people who helped with software for this book including Harald Heim (The Plugin site), Luc Marin (DxO Labs), Bill Dusterwald (Silver Oxide), Jan Esmann (Power Retouche); also to Michael Cutter (FreeGamma). Thanks to Judy Wong and Neil Hibbs of HARMAN technology Limited (Ilford Photo) who helped with information about the future of silver halide prints from digital sources.

Special thanks are due to Josh Nozzi of Bartas Technologies for his CopyWrite software <http://www.bartastechnologies.com>, which has proved a perfect project planner and document processor for this book.

Some of the quotes in this book come from interviews conducted by Anne-Celine Jaeger for her excellent book *Image Makers Image Takers* published by Thames & Hudson (2007). Data for the graphs on pages 85 and 100 are used with the kind permission of HARMAN technology Limited (Ilford Photo) and are taken from Pan F, HP5 Plus and Delta 3200 data sheets. Graphs on the sensitivity of the human eye on page 138 are from data used with permission from the Colour & Vision Research Laboratories at the Institute of Ophthalmology, UCL, thanks to Prof. Andrew Stockman.

As ever, I owe a debt of gratitude to my wife Alison for her unceasing support, critical judgement and keen-eyed proofreading.